THE END OF THE WORLD

CONTEMPORARY VISIONS OF THE APOCALYPSE

RUDOLF BARANIK

RICHARD BOSMAN

ROGER BROWN

LINDA BURGESS

BRUCE CHARLESWORTH

MICHAEL COOK

ROBERT FICHTER

REVEREND HOWARD FINSTER

DANA GARRETT

FRANK GOHLKE

LOUIE GRENIER

DONALD LIPSKI

MELISSA MILLER

ROBERT MORRIS

BEVERLY NAIDUS

HELEN OJI

JAMES POAG

KATHERINE PORTER

CRAIG SCHLATTMAN

MICHAEL SMITH with

ALAN HERMAN

NANCY SPERO

MARIANNE STIKAS

ROBERT YOUNGER

LYNN GUMPERT

THE NEW MUSEUM OF CONTEMPORARY ART

DECEMBER 10, 1983–JANUARY 22, 1984

LENDERS TO THE EXHIBITION

Robert Butler and Sonny Burt, Dallas, Texas
Castelli Graphics, New York
Friedus/Ordover Gallery, New York
Tracey Garet/Michael Kohn Gallery, New York
Germans Van Eck Gallery, New York
Robert H. Helmick, Des Moines, Iowa
Jones/Faulkner Collection, Chicago, Illinois
Phyllis Kind Gallery, Chicago, Illinois and New York
Monique Knowlton Gallery, New York
Bernard and Ruth Nath, Highland Park, Illinois
Patrick and Gwen Rodriguez, Chicago, Illinois
Sonnabend Gallery, New York
Barbara and Edward Spevack, Huntington, New York
Texas Gallery, Houston
Willard Gallery, New York

Library of Congress Catalog
Card Number: 83-43253
Copyright © 1983 The New Museum of Contemporary Art
583 Broadway, New York, New York 10012

ISBN: 0-915557-38-X

Essay © Lynn Gumpert

This exhibition is supported by grants from the National
Endowment for the Arts in Washington, D.C.; the New York
State Council on the Arts; and the Department of Cultural
Affairs, City of New York.

TABLE OF CONTENTS

PREFACE

IT IS WITH A MIXED SENSE OF OPTIMISM AND DESPAIR THAT we greet 1984, the Orwellian Year; it is a time of question and reflection, of inquiry into our society's state of affairs, and in our more specialized community, a time for re-examination of the state of the arts in which our lives are mirrored.

The End of the World: Contemporary Visions of the Apocalypse is an exhibition which addresses the real issues of our society's past, present and future in the face of the new potential for complete annihilation through nuclear holocaust or age-old threats of natural disasters. The exhibition is thus in keeping with The New Museum's policy of organizing thematic exhibitions which focus on issues whose scope and concerns are more than simply aesthetic.

My thanks to Curator Lynn Gumpert, who organized the exhibition and wrote the catalog essay under the most difficult conditions, in the midst of our move to new quarters. Our entire staff, including our interns and volunteers, has once again been instrumental in facilitating every aspect of the show, and deserves our deepest thanks for their hard work and dedication.

The exhibition has been generously supported by funds from the National Endowment for the Arts; the New York State Council on the Arts; and the Department of Cultural Affairs, City of New York. We are most grateful to the lenders for their assistance, and to the participating artists, who have shared their vision and their concern for the future of the world with us.

Marcia Tucker
Director

FOREWORD AND ACKNOWLEDGMENTS

THE "END OF THE WORLD" IS A MONUMENTAL, INDEED, overwhelming subject. Nonetheless, it has surfaced frequently as the theme of a number of group exhibitions. Among them in the New York area were *1984* and *Atomic Salon,* both at Ronald Feldman Gallery, New York, *Apocalyptic Visions,* at Galleri Bellman, New York, *The War Show,* Fine Arts Center, SUNY at Stony Brook, New York, *Dangerous Works,* at Parsons School of Design, New York, and *Anti-Apocalypse,* Ben Shahn Gallery, William Patterson College, New Jersey. However, most listed above were political in nature, a protest against the buildup of nuclear arms. No exhibition, to my knowledge, has attempted to place current apocalyptic tendencies within a broader historical and cultural context. And the subject, I feel, warrants serious and in depth attention. This, then, is the goal of the present exhibition.

This exhibition does not, however, purport to define a movement. Nor is it intended to be a definitive survey. Given the large number of potential, applicable works, selections were made to demonstrate the diversity in approach of those which directly refer to apocalyptic issues, either through title or imagery. A good number of artists who were not included also address these themes more obliquely – and often quite powerfully. For example, many artists have recently depicted war scenes, but here, I limited my selections to works which imply possible mass extinction through nuclear bomb imagery, or, on the other hand, natural catastrophes which could involve multiple deaths.

A number of friends and colleagues contributed sub-stantially to the genesis of the exhibition. To them, I am most grateful. Especially helpful was Phyllis Rosenzweig who generously made her files on this subject available to me. Fred Hoffman also shared ideas and thoughts, in addition to lending me a copy of his dissertation on Mark Tobey, a chapter of which treats apocalyptic issues in art generally, and their influence on Tobey specifically. Vicky Clark, Lucy Oakley, and Brian Wallis provided feedback and directed me to important references. Susan Kismarick made special arrangements to allow me to view photographs by Frank Gohlke at the Museum of Modern Art over the summer.

At The New Museum, I am most grateful to Robin Dodds (now at Hallwalls, Buffalo, New York) and Ned Rifkin for suggesting artists for possible inclusion. Marcia Tucker provided the title and aided in the initial formulation of the idea for the exhibition. Absolutely vital to its realization were Marcia Landsman and Lisa Parr (who organized the catalog) and John Jacobs and Eric Bemisderfer (who organized the transportation and installation). I would also like to thank Tim Yohn who, once again, sanguinely edited the manuscript, and Abby Goldstein who masterfully designed it, both under seemingly inevitable time pressures. Interns Celia Clarke and Debbie Zawadski worked through the heat of the summer and our difficult move to scout out initial research materials. My thanks also to Jeanne Breitbart and Alan Wintermute, who worked diligently on the biographies and bibliographies. I am indebted to those private collectors who generously lent their work to the exhibition. I am also most apprecia-

tive of the timely assistance of the following: Ted Bonin, Brooke Alexander Gallery, New York; Carol Celantano and Robin Lockett, Phyllis Kind Gallery, New York and Chicago; Bob Friedus, Friedus/Ordover Gallery, New York; Michael Kohn, Tracey Garet/Michael Kohn Gallery, New York; Bonni Benrubi and Tiana Winner, Daniel Wolf Gallery, New York; Fredericka Hunter, Texas Gallery, Houston; Nick Sheidy, Sonnabend Gallery, New York; and Renee McKee, David McKee Gallery, New York. My sincere gratitude also goes to the artists for their participation and for their willingness to share their thoughts and ideas on this theme. Finally, I dedicate this essay to Dennis Cate who provided patient editorial advice and unwavering support.

Lynn Gumpert

THE END OF THE WORLD:
CONTEMPORARY VISIONS OF THE APOCALYPSE

THE REALIZATION OF OUR INEVITABLE AND EVENTUAL DEATH influences, on some level, every aspect of our lives. It is precisely this awareness of mortality that distinguishes us from other forms of life. Likewise, the notion of the end of the world, encompassing individual deaths, has been an important preoccupation since the beginnings of civilization. Fears of potential cataclysmic endings have ranged from a fundamental concern that the sun would not return the next day to the elaborate, fantastic events detailed by St. John the Divine in his *Revelation*.

The invention of the atomic bomb, the devastating power of which was made all too horrifyingly clear at Hiroshima and Nagasaki, has kindled a contemporary awareness of a potential Armageddon. Both the approach of the second millenium and the year 1984, the symbol of a sterile Orwellian world immortalized in the futuristic novel, have added fuel to a growing malaise and anxiety. What are the effects of this apocalyptic awareness on society generally and on culture and the arts specifically? What is the function of art in an atomic age and is it possible to make meaningful comments in an age of "trendy despair?"[1]

This essay, then, examines the issues and raison d'être of work by twenty-four artists, which evokes feelings of impending doom. Although the earliest work in the exhibition dates back to 1966, the majority is from the last few years. Nor is subject matter of the art limited to the threat of nuclear extinction, but also includes a variety of catastrophic disasters. While these might not cause total annihilation, they allude to destruction of a cataclysmic nature, and thus act as metaphors for the end of the world. For the purpose of discussion, the types of ominous events pictured by the artists included in this exhibition have been grouped into several categories. The first consists of natural disasters such as floods (James Poag), tornadoes (Bruce Charlesworth, Linda Burgess, Frank Gohlke), volcanoes (Helen Oji, Marianne Stikas), and urban and technological disasters (Roger Brown, Richard Bosman, and Robert Younger). The second group contains references by the artists to a nuclear holocaust and its aftermath (Nancy Spero, Michael Smith and Alan Herman, Beverly Naidus, Louie Grenier, Donald Lipski, and Robert Morris). A third group consists of artists who have developed either formal or iconographic symbols in a personal vocabulary that once again conveys a sense of impending doom (Michael Cook, Craig Schlattman, Dana Garrett, Robert Fichter, Melissa Miller, and Katherine Porter). The fourth category includes two artists who, from totally different vantage points, prophesize the end of the world (Reverend Howard Finster and Rudolf Baranik). Many of the above artists do not profess to believe in an apocalypse *per se*. Yet all seem to be responding to a prevailing, pervasive sense of anxiety in society as well as to the specific potential apocalypse that has become possible with the creation of nuclear weapons.

• • • • •

In 1978, Christopher Lasch attributed the "storm warnings, portents, [and] hints of catastrophe [that] haunt our times"[2] to the rise of narcissism and an overreliance on a therapeutic culture. If best-seller lists are an indication of national preoccupations, Lasch's warnings would seem vindicated by the continued dominance of a variety of self-help and improvement titles. Indeed, two years later,

Lasch suggested that part of the enormous commercial success of his own best-seller, *The Culture of Narcissism: American Life in an Age of Diminishing Expectations,* was due to the fashionable interest in the notion of narcissism itself, and the "current fascination with psychiatric diagnoses of our cultural condition."[3]

Portents of doom were sounded more recently in Jonathan Schell's controversial best-seller, *The Fate of the Earth,* although he assigned them to a different and more specific cause.[4] In many ways, Schell's book is for the early '80s what Lasch's book was for the late '70s, an attempt to diagnose the renewed and intensified doom that pervades the social climate. Heralded no less as the "most important book of the decade.... Perhaps, the century," *The Fate of the Earth* first appeared serialized in the *New Yorker,* the second article in that journal's history to be uninterrupted by cartoons, and then was rushed into a hardback printing.[5] Essentially, Schell addresses the fact that the basic societal changes necessitated by our switch from a pre-nuclear to a nuclear society haven't been acknowledged. He warns of the danger of extinction, not just for ourselves, but also for the entire planet. We have not fully comprehended our peril because we continue to play by the rules of a society that didn't have total annihilation as a distinct and very real possibility. The failure to recognize the changed circumstances, Schell asserts, is, in part, a healthy form of self-protection – to avoid dwelling on potential death and extinction, and is thus a positive affirmation of life.[6]

With the harnessing of the immense power of nuclear energy, the potential for total destruction, either intentionally or accidentally, of the planet and of ourselves has been put into our hands. Previously, the end of the world was an event beyond human control. Indeed, the idea of an "apocalypse" is essentially a religious one. The word itself derives from the *Revelation* of St. John the Divine, the last book of the New Testament. "Apocalyptic" specifically refers to a body of literature emanating from a religious movement that began with Judaism during the third century B.C. and persisted through early Christianity into the Middle Ages. Following the cataclysmic destruction of the world predicted in apocalyptic literature is a renewed heaven and earth, a utopia where the just are resurrected and the Messiah comes to live among the people. This "divine intervention in human history to terminate the time of the evil world," should be distinguished from "eschatology," which is more cosmic in orientation and concerned principally with final, "last things."[7]

Now incorporated into general usage, these terms no longer necessarily imply specific religious meanings. Recently, the apocalypse was described as "a metaphor for the collapse of capitalism"[8] and eschatology was identified as a "study of the world's end that ignores religious beliefs or puts old visions to use as metaphors for modern anxiety."[9] Meanwhile, accompanying these secularized interpretations of the end of the world is a religious, evangelical revival which predicts a whole slew of doomsdays. The number one, nonfiction best seller of the 1970s, Hal Lindsay's *The Great Late Planet Earth,* which sold over 15 million copies, attests to the widespread, popular interest in a Biblical Armageddon.[10]

In addition, apocalyptic themes have inspired a substantial and important body of visual interpretations. Many early versions exist either as manuscript illuminations which illustrate apocalyptic texts or in the form of sculptural tympani of Last Judgment scenes. One notable example is Albrecht Dürer's *Apocalypse* of 1497–98, in which he condensed the lengthy texts into fifteen powerful woodcuts. Later, other artists were similarly drawn to the *Revelation* for its drama and rich symbolic references containing prophesies of both tragedy and hope. William Blake also illustrated the Biblical passage, but considered the apocalypse an intensely personal experience for each individual which could occur at any moment when evil was recognized. For him, the *Revelation* and the Last Judgment were internal affairs of the Spirit.[11] Still later, Wassily Kandinsky, in a series of paintings with titles such as *Riders of the Apocalypse, Deluge* and *Last Judgment,*

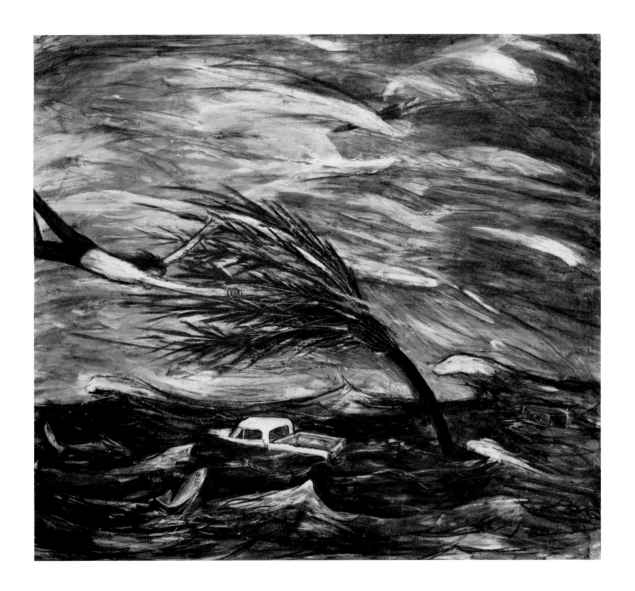

1. JAMES POAG
 Storm, 1983
 Gesso, acrylic and litho crayon on paper mounted on canvas, 62 x 68½ inches
 Collection of the artist

expressed his belief that the coming cosmic destruction would be followed by the "Great Epoch of the Spiritual."[12] For Mark Tobey, the *Revelation* contained similarities to central tenets of the Bahá'í faith and his personal beliefs that art could serve as a catalyst for an essential transformation of consciousness and thus served as an important source for the mural study, *The Portrait of an Artist as an Old Man.*[13]

As far back as the Renaissance, artists deviated from strict Biblical interpretations in depicting the end of the world. A careful observer of the forces of nature, Leonardo da Vinci made realistic studies of patterns of swirling water, which soon evolved into the apocalyptic drawings known as the "Deluge" series. Sir Kenneth Clark has noted that the late fifteenth century saw a new proliferation of apocalyptic writings which prophesized a specific end to the world by deluge. Despite their condemnation by the Church, these writings were immensely popular and influential, at times inspiring the abandonment of entire villages. Of the effect of these doom-filled warnings on Leonardo, Clark writes:

They correspond with his own deepest belief: that the destructive forces of nature were like a reservoir, dammed up by a thin, unsteady wall, which at any moment might burst, and sweep away the pretentious homunculi who had dared to maintain that man was the measure of all things.[14]

Likewise, contemporary artists can be viewed within this art historical continuum, and their apocalyptic works include both interpretations of the *Revelation* as well as depictions of natural disasters. Among the latter, the theme of deluge is one of the oldest, figuring prominently in almost all ancient cultures and mythologies. The Judeo-Christian heritage is no exception, and while the rain did not last the proverbial forty days and nights, the havoc wreaked by this past summer's hurricane Alicia on Texas was considerable. It also provided James Poag with a powerful experience of a hurricane. In *Storm,* 1983, a lone figure clings desperately to the limb of a windblown tree while the storm waters continue to rise, carrying with them an abandoned car. Adding to the chaos and destruction, an unexplained and mysterious missile hurtles through the cloud-filled, turbulent skies (fig. 1). Nature's vengeful side is once again portrayed by Poag in *Plants Marching on the City,* 1983. In this work, an ominous army of vegetation looms menacingly in the foreground, threatening to overtake a cluster of highrise buildings. This more visionary and imaginary scene of disaster shares certain similarities with science fiction, for which the end of the world is familiar territory.

Linda Burgess, like James Poag, began to depict scenes of natural disasters when she relocated to an area susceptible to them, in her case, Alabama. Intrigued by the changes that occurred in the lush, pastoral landscapes of rural Alabama with the advent of a tornado, Burgess began a series of drawings in 1980 devoted to them. The early works of this series usually depict a solitary two-storied farmhouse. In *Impending Storm,* 1981, the sky fills nearly three-quarters of the composition in a manner reminiscent of seventeenth-century Dutch landscape paintings. Yet here the darkened sky appears threatening, as if it were about to crush the diminutive houses below it. In *Exploding House,* 1980, we are brought in much closer to witness the moment of impact as the house literally disintegrates, boards and debris flying in all directions (fig. 2). Compared to Poag, Burgess prefers a more realistic mode of depiction, almost documentary in its attention to detail. Poag, on the other hand, eschews realism for a more expressionistic mode, relying more on his imagination than on observation.

Frank Gohlke literally documents the impact of a tornado in his series of black and white photographs, *Aftermath: The Wichita Falls Tornado,* 1979–80. Gohlke returned to his home town upon hearing of the tornado that struck there in April 1979, leaving a one-mile wide, ten-mile long trail of near total devastation. Having grown up with the constant threat of a tornado a very real possibility, Gohlke felt the need to see the destruction for himself. Without advance planning, and almost instinctively, he

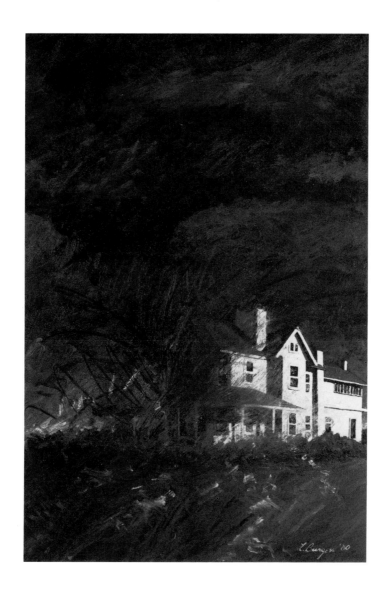

2. LINDA BURGESS
 Exploding House, 1980
 Oil and craypas on paper mounted on canvas, 30 x 20 inches
 Collection of the artist

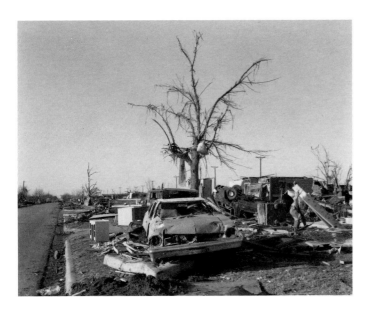 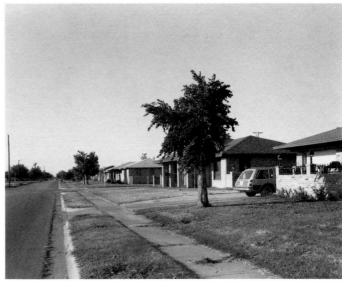

3. and 4. FRANK GOHLKE
 Aftermath: The Wichita Falls Tornado, 1979–80
 "#11A, 4503 McNeil, Looking North, April 14, 1979,"

"#11B, 4503 McNeil, Looking North, June 1980,"
Gelatin silver prints, 16 x 20 inches
Collection of the artist

began photographing. In *McNeil Looking North*, a tree located in the center provides a stabilizing compositional feature, but everything else is in chaos, as if the house were turned inside out (fig. 3). A car rests upside down and a mattress tilts at a 45-degree angle. The scene of devastation is made even more compelling when compared to the photograph taken at the same spot a year later (fig. 4). Here, everything is in order, from a car parked in the driveway to a neat and tidy suburban home. After shooting the initial scenes, Gohlke realized that they were somehow incomplete, which gave him the idea of returning, a year later, to document what had happened to the town since. Disasters, "violent disruptions that rip the fabric of our society...are the communal tragedies that underline the schizophrenic nature of our existence."[15] Gohlke was interested in recording the human response to the enormous expenditure of energy generated by the tornado. He found that the overwhelming tendency was to replace or put back everything in the most exact manner possible, rather than changing or improving, in a way denying that the tornado had ever happened. The return of order, as the people of Wichita Falls knew it, seems to have been paramount.

Gohlke later indicated that his need to experience that particular event personally, was, in part, a reaction to television's reduction of all catastrophes to the same level.[16] With the advent of mass communications, disasters have become commonplace, entering our homes daily via television news where reports and footage of disasters dominate. Although they may occur in distant, often remote locales, they are featured prominently on local news, especially when accompanied by detailed, explicit footage.[17] The apparent appeal of disasters inspired Hollywood filmmakers in the 1970s to produce a whole series of "disaster flicks" on a variety of catastrophes including earthquakes, tidal waves, volcanoes, and fires.

Andree Conrad, in an article on disaster and the American imagination, attributes the enormous success of disaster entertainment to the fact that it provides one means of confronting the terror of death, taking us "beyond the lonely existential encounter to provide us with the anodyne of mass death, as sanitized and democratized by special effects." Identifying a "panic principle," she also warns of an habitualization to the idea of violent mass death, which thus engenders a "false sense of bravery about...nuclear disaster."[18]

Mass media's anesthetized handling of disasters is one aspect of Bruce Charlesworth's installation, *Projectile*, 1982, a portion of which has been excerpted for this exhibition.[19] Charlesworth was inspired, in part, by the warnings broadcast over the radio before, rather than the coverage after, a tornado touched down in Minneapolis, a few feet from Charlesworth's home. The eerie disjunction between the uninflected voice calmly describing procedures to follow in case of a touch down and the actual havoc and terror of when it did was translated into one element in a complex narrative for the installation's accompanying videotape (fig. 5). In the *Projectile* videotape, which recalls the themes of intrigue, interrogation, and surveillance of his earlier work, Charlesworth plays Johnson, a suspect in a crime who is tailed by a detective. After a series of bizarre occurrences, including assault, Johnson ends up in the home of a militant survivalist, complete with bomb shelter. The survivalist and his girlfriend, possibly a narcoleptic and obsessed with weather, represent to Charlesworth two views of disaster.[20] The mood of apprehension and imminent danger, which had slowly been building up, reaches a climax when there is a sudden explosion, the camera lurches violently, and panic ensues. The projectile itself is never explained and the text ending the tape suggests: "Maybe it was a torpedo flung from a passing sub, or debris whisked in by one of those coastal storms. Whatever it was, it left a gaping hole in the ceiling, and a mess on the floor."

A massive boulder, or perhaps meteorite, hurls down from the sky in Helen Oji's *Earth Cracks (Volcano Series #41)*, 1983 (fig. 6). As with Charlesworth's *Projectile*, we are not sure of the cause, but both evoke a terror not unlike that of Chicken Little's when he was convinced

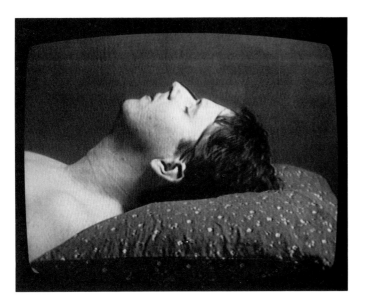 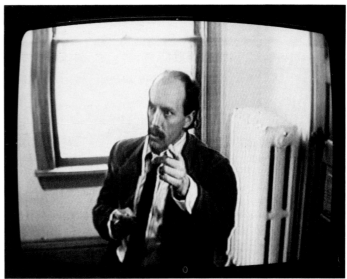

5. BRUCE CHARLESWORTH
 Stills from *Projectile*, 1982
 Color videotape with sound; 18 minutes
 Collection of the artist

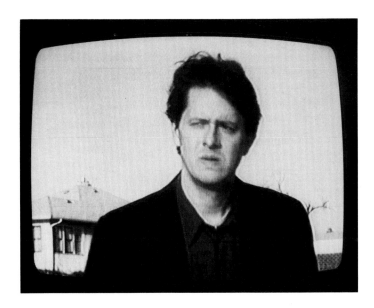

For Marianne Stikas, the eruption of Mount St. Helens also had an impact, although it did not surface formally in her art until a year or so after the event. The volcanic imagery coincided with a time of stylistic change, but in addition, one of personal turbulence and struggle as well. Whereas Oji's volcanoes are clearly identifiable as such, Stikas' approach is more generally apocalyptic in feeling. In *End of the World with a Halo*, 1982, a stylized, central, red volcano sputters while waves surge up at its foot and sides. The "halo," a spiral which swirls out one side, and mysterious lozenge-shaped, missile-like clouds drift downward. The scene becomes even more fantastic in *Radioactive Landscape*, 1982 (fig. 7). Here a black volcano is silhouetted against a hot, pink sky in the left-hand background, while in the foreground blue flames dance out one amphora, while another is thrown askew by a tidal wave. It is as if the four elemental forces of earth, water, wind, and fire are raging out of control, combining and conflating into one grand apocalypse, heightened further by the acid colors, hectic composition, and sweeping brushstrokes.

The painterly expressionism of Stikas' paintings contrasts sharply with the iconic, distinct execution of Roger Brown's "Disaster Series." Begun in the summer of 1972, Brown painted a series of catastrophic disasters including earthquakes, fires, avalanches, tornadoes, airplane crashes, and explosions, among others. Brought up in the evangelical atmosphere of Southern fundamentalism, the religious images of hell fire and brimstone were easily transformed into scenes of urban calamities. In addition, Brown was drawn to the disasters headlined in the morning newspapers and featured on the evening news as subjects for his paintings. In *Ablaze and Ajar*, 1972, symmetry, a hallmark of Brown's style, still reigns, despite the havoc of the scene. Also familiar are the small, black silhouetted, forties-style figures seen through the windows of the tumbling *art moderne* skyscrapers. About the disjunction between the concise, almost iconic manner of execution and the startling subject matter, Mitchell Kahan notes:

that the sky was falling in the popular children's story. In Oji's large black and white drawing, the danger is intensified since a large chasm in the earth has opened menacingly in the foreground. Here, both ground and sky are unsafe in this double cataclysm. We can measure the enormity of the calamities by the tiny figures in the upper left-hand corner, one fleeing in horror, the other oblivious, perhaps photographing an earlier crater, still steaming. In another work, *Clouds of Stone: (Volcano Series #42)*, 1983, we witness a more distant eruption of a volcano, which spews forth clouds of smoke and stones. The "Volcano Series" signals a radically new direction in Oji's work. The eruption of Mount St. Helens in Washington, which received a good deal of media coverage, coincided with Oji's need for stylistic change. Her first depiction of Mount St. Helens occurred within the kimono-shaped format she had worked with for seven years. The volcanic eruption, which altered the Washington landscape and which was reminiscent of disasters in science fiction films to which Oji had long been attracted, provided the impetus for her change in format.

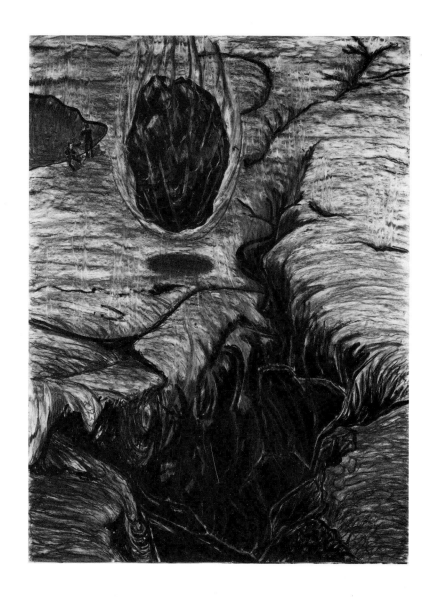

6. HELEN OJI
 Earth Cracks (Volcano Series #41), 1983
 Charcoal and acrylic on paper, 96 x 72 inches
 Courtesy of Monique Knowlton Gallery, New York

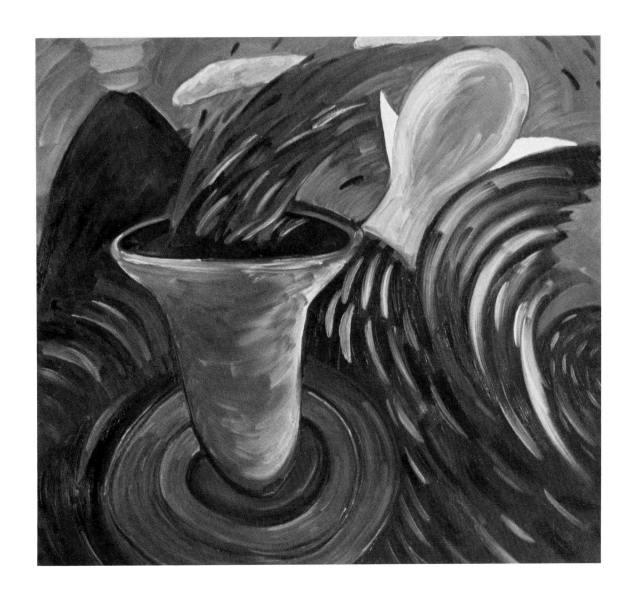

7. MARIANNE STIKAS
 Radioactive Landscape, 1982
 Oil on canvas, 54 x 60 inches
 Collection of the artist

Brown leaves the viewer quite conscious of the discrepancy between the real meaning of the disasters and the artful effects his depictions stress. It is this offhand treatment which is most shocking, not the images themselves. The result is highly subversive, for the viewer is uncomfortably forced to accept the horrific in the same manner as he views the ordinary and the beautiful.[21]

Whereas we view the tiny participants of Brown's disasters from a distance, the figures in Richard Bosman's *Panic*, 1982, appear larger than life (fig. 8). They rush headlong into the viewer's space, fleeing the fire and destruction behind them. As in other works, such as Charlesworth's videotape or Oji's drawings, the nature of the calamity remains unclear. Whatever the cause, cars sink into the crevices, buildings lean at precipitous angles, and fires rage out of control. This is the moment of impact, the second of seven stages used to describe human response to natural catastrophies. Conrad describes the loss of lifetime illusions of invulnerability experienced during impact:

The disorder's sudden, traumatizing invasion shatters the mind's defense perimeters, which from childhood it had so carefully constructed, to weed out that immense amount of reality that wasn't "relevant." Not bits and pieces, but the totality of the disorder penetrates, stages a massive instantaneous invasion of all five senses. One is filled with this sudden, intractable mess, just as one is filled with the disordering evil spirits of disease.[22]

The panic-filled reaction pictured in Bosman's painting approaches scenes from disaster films and television news clips, the latter an important source for Bosman's choice of subject matter. The painting enlarges the theme of violence in his earlier work but is also drawn from his experience as a 14-year-old, when he was caught in the middle of riots which occurred with Nasser's expulsion of the French and British from the Suez Canal where Bosman had lived for the previous ten years. Another source of inspiration are reports from the terror-ridden ambience of the Middle East, and specifically of Beirut, the title of a recent painting of a mass disaster.[23]

Bosman, Poag, and Brown situate the scenes of their disasters within a specifically urban setting, although the latter two have depicted natural, rurally-situated catastrophes as well. In doing so, they comment on the fact that despite ever-increasing technological sophistication, we are still at the mercy of nature. Indeed, Charlesworth specifically mocks the technology which provides better warnings of impending disasters, but essentially is helpless to do anything to prevent them. The drama of an urban disaster lies not only in the impressive devastation of massive skyscrapers, but also in the large numbers of people affected. The tornado that demolishes Burgess' solitary farmhouse, affecting one family, is magnified many-fold by the towering infernos of Brown's highrises. The human drama increases proportionally, as does the expense involved, one of the primary factors determining the "rating" of importance of a disaster.

In addition, technology itself has created new, potential catastrophes. To highrise holocausts previously mentioned, we can add airplane crashes, and nuclear plant accidents, in addition to the more obvious threat of nuclear war. Sophisticated technology, which now allows us to measure and predict various dangers to the biosphere, has also created pollution. In the last decade, knowledge of natural sciences has also greatly increased, making us aware of potential astrophysical, geological, climatological, biological, and ecological disasters.[24]

Robert Younger dealt with one such possible global catastrophe, heat death, in a 1977 installation in Philadelphia.[25] He provided a definition of heat death in the installation itself: "The energy of the universe is slowly passing into heat, uniformly distributed and therefore unavailable as a source of useful work. Eventually it is thought that by this dissipation of energy the universe must become motionless and dead." Another definition of this version proposes the possibility that the more immediate heat generated by our industrial, nuclear-powered society will not be radiated into space fast enough to prevent the planet from becoming literally too hot to live on.[26]

Younger's interpretation relied on a total manipulation of the viewer's perception of the installation space to create abstracted metaphors for issues dealing with entro-

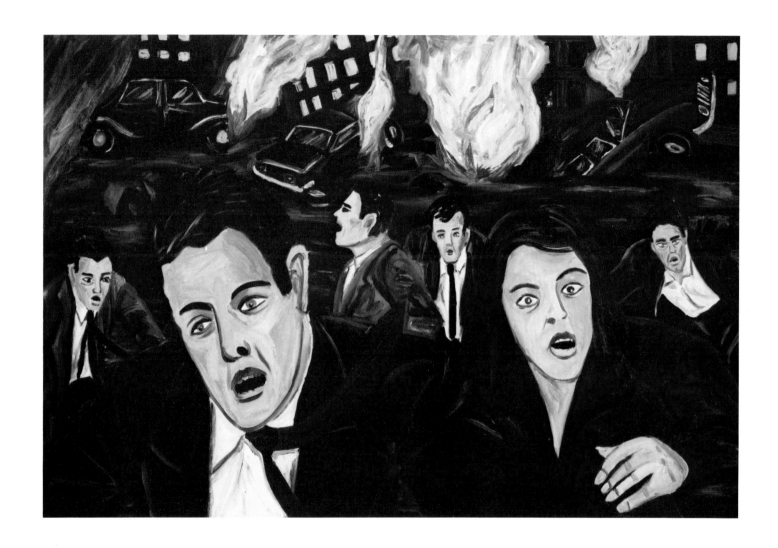

8. RICHARD BOSMAN
 Panic, 1982
 Oil on canvas, 79 x 108 inches
 Collection of Robert H. Helmick, Des Moines, Iowa

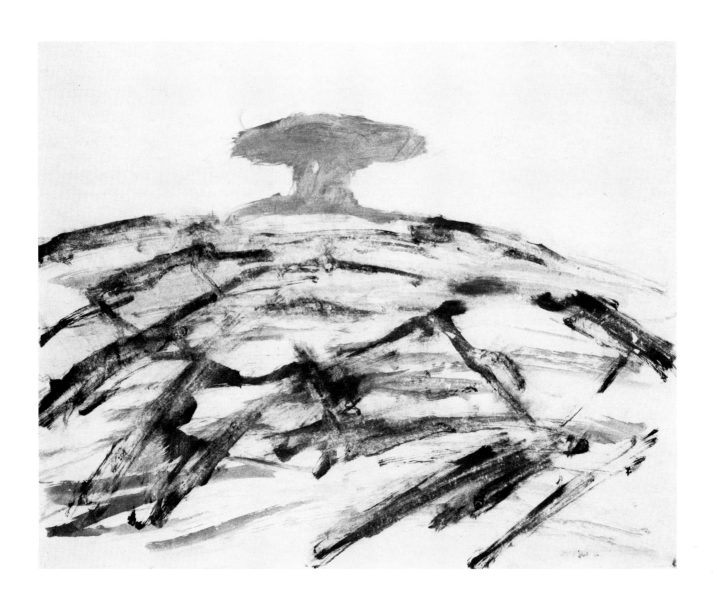

9. NANCY SPERO
Bomb-Victims, 1966
Gouache and ink on paper, 27¼ x 34 inches
Courtesy of Willard Gallery, New York

phy, planetary extinction, and the passage of time.[27] Constructing three distinct chambers, Younger was able to control both light and temperature. The first chamber contained a suspended light bulb with instructions to the viewer to swing it from side to side. A miniature sun, it provided the only source of light, and when moving cast a myriad of complex shadows, also symbolizing entropy as it slowed down. The second chamber was marked by a skeletal facade of two-by-fours, containing a schematized dog and leading into the third, darkened chamber with a sink and a wheelbarrow coffin. Critic Jeanne Silverthorne notes the evolution from "pure energy (the bulb) to animal existence (the dog) to human mortality (the casket), an evolution doomed to extinction beforehand."[28]

• • • • •

It is this more sinister side of technological and scientific evolution in the form of nuclear energy which provides the inspiration for the next group of artists. Jonathan Schell comments on the irony that the "fundamental origins of the peril of human extinction by nuclear arms lies not in any social or political circumstances of our time but in the attainment by mankind as a whole of a certain level of knowledge of the physical universe."[29] Thus it is not surprising that, as Susan Sontag has noted in a 1965 essay on science fiction films and the imagination of disaster, in certain movies of the 1950s and '60s, the awakening of a prehistoric, super-destructive beast serves as an obvious metaphor for the Bomb.[30] Sontag goes on to discuss science fiction films as modern allegories of dealing with the perennial human anxiety about death, but with a new twist which has intensified the anxiety, specifically:

The trauma suffered by everyone in the middle of the 20th century when it became clear that, from now on to the end of human history, every person would spend his individual life under the threat not only of individual death, which is certain, but something almost unsupportable psychologically – collective incineration and extinction which could come at any time, virtually without warning.[31]

In the 1950s and early '60s, the threat of an apocalypse appeared imminently possible in the form of a nuclear holocaust. Atmospheric testing of ever more powerful nuclear bombs was continuing and the stockpile of arsenals grew. Yet with the treaty between the United States and the USSR banning atmospheric testing for nearly two decades and as testing went underground, nuclear weapons "stayed dormant, wrapped in the metaphysics of war gamesmanship, a megacalculus of deterrence, retaliation, and overkill, and the fears of a nuclear holocaust seemed to fade."[32]

Yet as early as the mid-'60s, when most preferred not to confront the issues of increasing nuclear threat, Nancy Spero began depicting the mushroom-shaped cloud in a series of works on paper. Returning from France to New York in 1966, Spero reacted strongly to the Vietnam War. The bomb, a symbol of total destruction, underwent various transformations. Spero commented on "this terrific outburst...[where] the bombs became very sexual and very phallic. Mostly male bombs – a long penis with heads at the end of the penis.... On top of the bomb cloud there were heads spewing out poison or vomiting or sticking their tongues out."[33] The sexual metaphor was not limited to males, but also took female form symbolized by breasts, at times the two coexisting. The idea of sexual energy transformed into a violent destructive force extended also into defecation and self-regeneration, the heads of certain bombs turning back and licking themselves.

One source of inspiration were the medieval manuscript illuminations of an apocalyptic text by a nun, Ende.[34] Although she does not relate to the salvation scheme inherent in the Christian interpretation, Spero has commented on a similarity in the "dislocation and stylization...[to] medieval prototypes."[35] The spontaneous and delicate execution of these works contrasts sharply with their horrific content. In *Bomb-Victims*, 1966, a salmon-colored cloud rises above strokes of greys and pinks, which, when examined more closely, are revealed to be outstretched, agonized bodies (fig. 9).

Michael Smith's and Alan Herman's collaboration in

the installation, *Government Approved Home Fallout Shelter Snack Bar,* 1983, triggers memories of the more panic-filled days of the '50s (fig. 10).[36] Here, Smith and Herman have created the home basement of Smith's alter-ego, "Mike," complete with the pre-packaged government build-yourself bombshelter that doubles as a snack bar. The strength of the installation lies in its absolutely convincing banality – it is the paradigm of Middle America's basement, complete with washing machine, dryer, odds and ends, and adjoining "recreation room." The accumulation of details, the bits and pieces of a person's life, represented in this two room installation, juxtaposed with the semi-disguised and totally ineffectual snack bar-fallout shelter, underscores the omnipresent threat of total annihilation underlying our everyday existence, as well as the failure to really totally comprehend the danger. As Christopher Lasch notes: "Impending disaster has become an everyday concern, so commonplace and familiar that nobody any longer gives much thought to how disaster might be averted. People bury themselves instead with survival strategies, measures designed to prolong their own lives, or programs guaranteed to ensure good health and peace of mind."[37]

The futility of the snack bar, with "hinged canopy that can be tilted down for filling with brick or concrete blocks" culminates in the videogame accompanying the installation.[38] Programmed by a high school, computer-game expert, the object is to get "Mike" to carry three concrete blocks up a set of stairs in between the air raid siren and fireball. One false step, and he tumbles down the stairs and eventually the Manhattan skyline viewed through the living room window disintegrates. The tension mounts as minutes tick away – finally all is destroyed in the awaited blast, to the theme song from the movie *Dr. Strangelove.* The "game" mimics the destruction and violence of its video counterparts.

Whereas Smith's installation sets the scene of a bomb shelter before an atomic attack, Beverly Naidus' installation, *This is Not a Test,* first exhibited in 1978, takes place in a basement apparently after an attack (fig. 11). Naidus,

like Smith, remembers vividly the atmosphere of her childhood in the '50s, the classroom drills in case of nuclear attack, and the Cuban Missile Crisis. Naidus explains: "To children growing up in a sheltered New Jersey suburb, the threat of a nuclear holocaust seemed a joke. And yet, we had to memorize the difference between long and short sirens: one meaning the bomb had already fallen on New York City and we had to stay in school, hiding in the hallways, and the other meaning the attack had not yet been launched and we still had time to run home."[40]

Her installation creates the darkened space of a basement, with a bed supporting a miniature landscape setting of precipices, and deadends, symbolizing physical decay and futility. Yet contrasting with this scene of desolation is a series of tiny projected slides of pastoral landscapes, triggering memories of what had once been.

Uniting these various elements is a six-minute soundtrack of a conversation, one voice, serious and slightly panicked, the other cynical and offhand. The first questions the failure to perceive what is happening, the second answers cynically, suggesting government put-ons and to "get your kicks while you can." Meanwhile, a radio announcer interrupts to "bring...a special announcement. You are advised to proceed..." A cut to another voice, not unlike a "whiney school teacher" brings us back to the practice air-raid drills which Naidus, in retrospect, asserts that "although [they] seemed like an elaborate game at the time, the effect was much more frightening and profound. In many subtle ways, it has taught a whole generation not to care too much about the future, not to confront a harsh reality because it hurts too much."[41] Whereas Smith deals with specifics, Naidus manipulates generalities to question our sense of futility and apathy. All too convincingly, she has created a post-nuclear dialogue that might possibly take place, should anyone survive.

Louie Grenier, like Naidus, confronts the absurdity of life after a nuclear holocaust in *Pass Debris,* 1982, a color videotape with Grenier playing the protagonist engaged in conversation with an off-camera stranger (fig. 12).

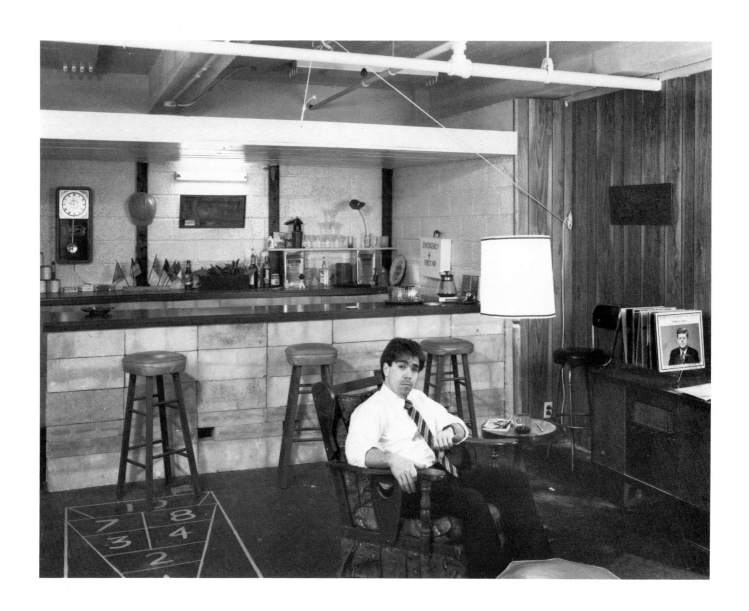

10. MICHAEL SMITH with ALAN HERMAN
 Installation view of *Government Approved Home Fallout Shelter Snack Bar,* 1983
 Mixed media, dimensions variable
 Courtesy of Castelli Graphics, New York

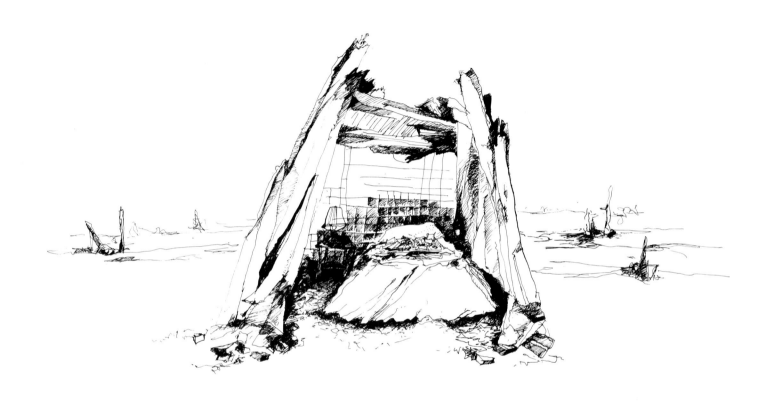

11. BEVERLY NAIDUS
 Study for *This is Not a Test,* 1978–83
 Ink on paper, 22 x 30 inches
 Collection of the artist

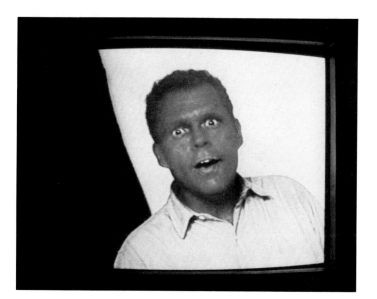
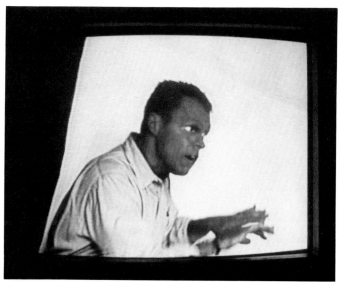
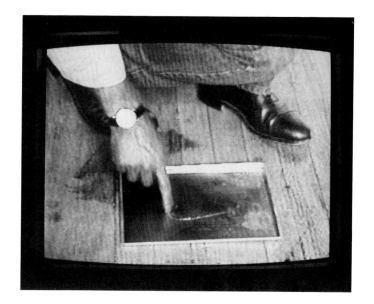

12. LOUIE GRENIER
 Stills from *Pass Debris,* 1982
 Color videotape with sound; 3 minutes, 42 seconds
 Courtesy of Castelli-Sonnabend Tapes and Films, New York

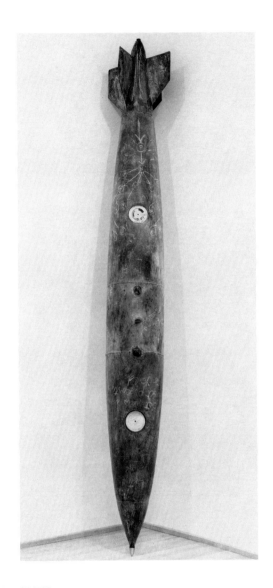

13. DONALD LIPSKI
Building Steam (#63), 1981
Demolition bomb, graphite paint, chalk, stainless steel and NATO kilotonnage
calculators, 120 x 14 x 14 inches
Courtesy of Germans van Eck Gallery, New York

Distorted camera angles, a diagonal horizon line, and Grenier's reddened complexion create a sense of disorientation, a world gone awry. Grenier attempts to give directions to get uptown, via Connecticut, by taking "a left at the fireball," since central Manhattan is full of debris. Absurdities abound as Grenier draws a map in a pan of oil, and suggests that it was not China who caused the nuclear holocaust, but rather the conflict between Manhattan's Chelsea and garment district, and then absurdly offers ice cream.

Donald Lipski's sculptures often look as if they could have been constructed out of the debris left from a nuclear explosion. Discarded objects found on the street are combined with odds and ends from hardware stores, then transformed and manipulated into mutant variants of what they once were. They could be obsolete fossils unearthed by future archaeologists looking for remnants of our industrial civilization.

The titles of the two sculptural series, *Gathering Dust* and *Building Steam,* both imply a sense of anticipation, one more passive, the other more active. The impetus for *Building Steam,* from which the two sculptures in this exhibition belong, grew, in part, from an experience Lipski had while watching a sunrise at the ocean. Disturbing the quiet solitude at 5:00 a.m. were four A-6 fighter planes which zoomed by overhead. The contrast between the idyllic beach scene and the fighter planes struck a disquieting note and suggested the possibility of calamity when least expected. His work from this series reflects in an oblique manner an impending explosion. The two works included here, however, are much more direct. In one, Lipski has covered a found, 2,000-pound demolition bomb with graphite and chalk, drawing scientific-looking diagrams over it with phrases such as "cost rises in direct proportion to yield" (fig. 13). In the other work, he has transformed a fifties-style vacuum cleaner into a missile-like bomb. Resting on stacked sheets of glass, it is combined with a twisted and bent fork, covered partially with red plastic. Lipski uses to his advantage the aerodynamic tendency of late twentieth-century industrial

design to comment on the potential danger of technological advancements, such as the creation of the thermonuclear bomb.

In his *Firestorm* drawings, Robert Morris directly confronts the horror of an atomic explosion. The title describes the second phase after the fission and fusion reactions have occurred, causing a huge fireball to take shape, which, in turn, generates mass fires.[42] "Firestorm" also recalls the "black rain" of mud, ash, and radioactive fallout which fell on the devastated city of Hiroshima on the morning of August 6, 1945.[43]

In looking at the more monumental works of this series, the viewer is engulfed in waves of blacks and greys (fig. 14). What look to be three-dimensional posts provide a geometric structure for the tormented swirls of forms, and also suggest the remnants of an architectural structure soon to be devoured by the flames. Barely discernible are the suggestions of skeletal vestiges of incarcerated bodies. These works, as well as his concurrent "Psychomania" drawings and the "Hypernotomachia" reliefs, borrow from Leonardo's *Deluge* drawings as well as the visionary scenes of William Blake and more traditional catastrophes such as Théodore Géricault's *Raft of the Medusa*. In their monumentality, overall composition, and the addition of unidentified narrations based on descriptions by Hiroshima and Nagasaki survivors, they are at once contemporary yet timeless. Their enormous impact derives from their lack of specificity, relying on abstract forms to evoke feelings of nightmarish desolation.

• • • • •

In *The Fate of the Earth,* Jonathan Schell comments on the difference between Newtonian and Einsteinian physics, the former being human-scaled and "valid for velocities and sizes commonly encountered by human senses," the latter leading to "investigations into realms of the irreducibly small and the unexceedably large [examining] the properties of energy, mass, time, and space in the subatomic realm and the cosmic realm."[44] Both Einstein's theory of relativity and Heisenberg's principle of uncer-

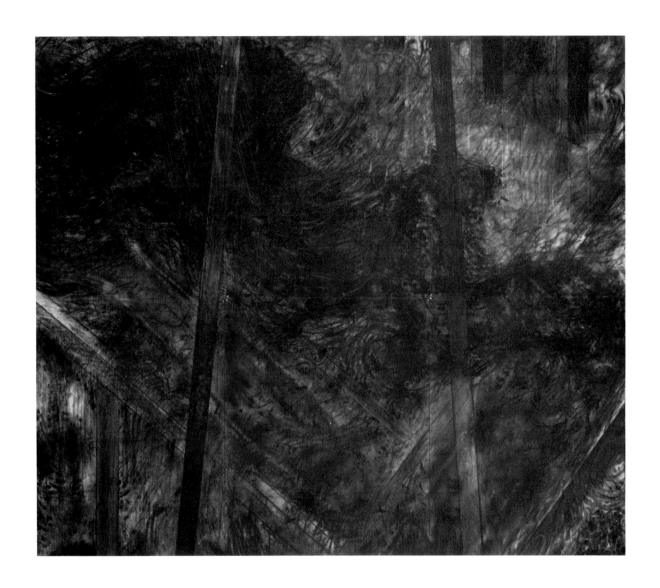

14. ROBERT MORRIS
 Untitled (#10977) from *Firestorm* series, 1982
 Charcoal, ink, graphite on paper, 100 x 114 inches
 Courtesy of Sonnabend Gallery, New York

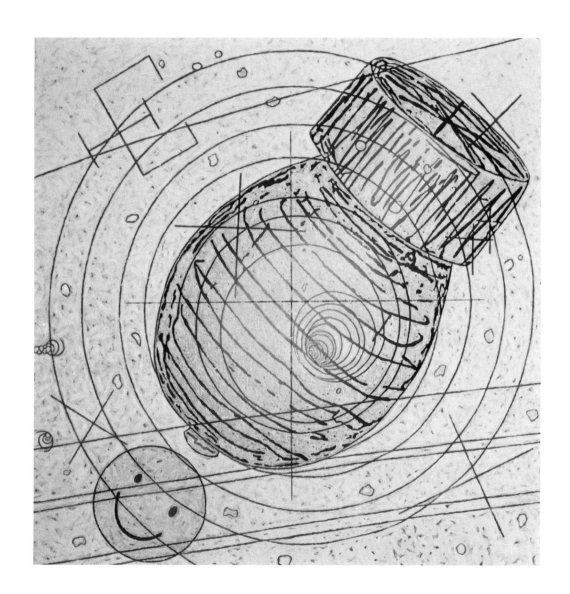

15. MICHAEL COOK
 Ashes, 1982
 Oil on canvas, 72 x 72 inches
 Collection of the artist

tainty, then, have radically altered the way in which we perceive the universe. And an ominous by-product is the capacity for our planet's total annihilation.

In his art, Michael Cook juxtaposes the centuries-old science of alchemy with ultra-modern physics, specifically that of the collision of subatomic particles in a bubble chamber. Interested in the unification of opposites, Cook examines both the positive and negative aspects of science, the old and the new, the beautiful and the horrific. The two paintings included in this exhibition focus on science's destructive side. In *Ashes*, 1982, a nuclear bomb is aimed at a "happy face" symbol, both overlaying a linear system of lines and curves (fig. 15). Derived from both 90mm bubble chamber film of subatomic particles and alchemical symbols, the two are formally very similar, at times almost indistinguishable from one another. To Cook, the resemblance underscores the continuity of life and the fact that modern chemistry developed from the occult and ancient desire to transfer one mass, base lead, into another, gold.[45] Harrowingly beautiful is *Work Completed*, 1982, in which the alchemical sign for the title, consisting of a diamond and cross, is repeated ad infinitum into the distance, creating the image of a cemetery. Cook, then, ironically questions whether all "work" will cease, or be completed, with our own destruction.

Susan Sontag has noted that science has always been perceived as a type of magic and that we have always suspected that black magic exists. In science fiction, then, the scientist appears both as satanist and savior, a role that has now been expanded beyond the sphere of the local community into the cosmos.[46] In a series of color photographs, Craig Schlattman portrays the scientist as part magician and part huckster. Constructing his own, albeit, primitive sets, and with himself as the white-smocked protagonist, Schlattman delivers nonsensical visual interpretations and explanations of the basic laws of physics (fig. 16). This series humorously attempts to demystify what most people perceive as esoteric and incomprehensible. Schell, in discussing the scientific origins of our current predicament, notes the differences between social and

scientific revolutions since the former "cannot occur unless they are widely understood and supported by the public" whereas the latter "usually take shape quietly in the mind of a few men, under the cover of impenetrability to most laymen of scientific theory, and thus catch the world by surprise."[47]

Schlattman's interest in the physics he had learned in high school and college reveals a desire to understand the basic laws of existence. Although not apocalyptic in intent, Schlattman grapples with the idea that scientific progress has led us to the discovery of energy powerful enough to cause our self-destruction.

Another aspect of the scientific revolutions is their universality and permanence – in other words, they can never be unlearned. Thus the only way of "getting rid of the knowledge of how to destroy ourselves would be to do just that – in effect, to remove the knowledge by removing the knower."[48] An additional irony is that our knowledge of the earth's resiliency to nuclear attack "is limited because the experiments with which we would carry out our observations interfere with us, the observers, and, in fact, might put an end to us."[49]

Likewise, we can never really experience our own individual death since, with loss of life, we lose the ability to experience. Dana Garrett, however, approaches what can be imagined as the experience of death. Through his magnification of traditional symbols of death, skull and skeleton, he provides "the closest idea of a vision of a living human consciousness of death," in an indistinct world of grays and blacks.[50] In *Welcome*, 1982, a mammoth skull occupies a fourth of the canvas, seen against an abbreviated and bleak urban landscape (fig. 17). Because of the reverse, upward perspective, we lose our balance and ability to ground ourselves. The painting evokes a disorienting, timeless sensation of mass death, that of an entire city, perhaps the world, while also recalling medieval interpretations of the Dance of Death, especially popular at the time of the Black Death.

Skeletons appear in Robert Fichter's work, but in contrast to the reductive simplicity of Garrett's work, they

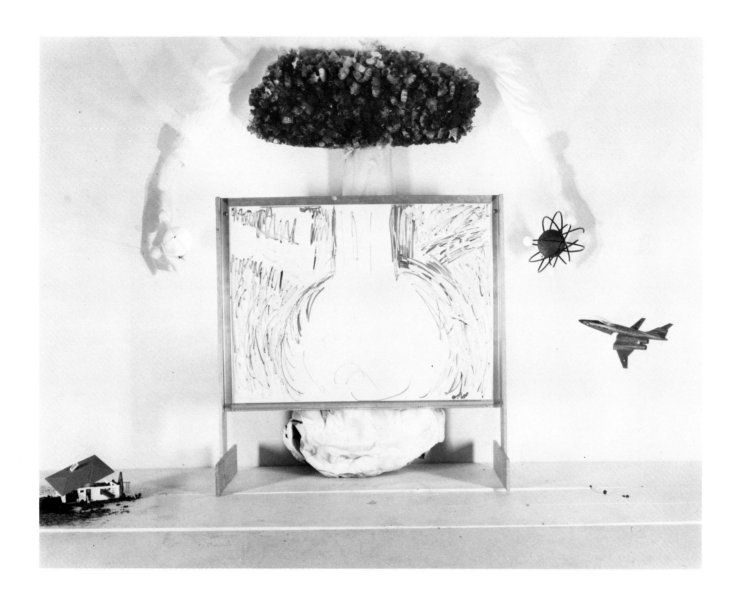

16. CRAIG SCHLATTMAN
 Fission Experiment (Homage to Oppenheimer); When a Neutron Collides with
 a U-235 Particle, Fission Could Occur, 1982
 Type-C print, 20 x 24 inches
 Collection of the artist

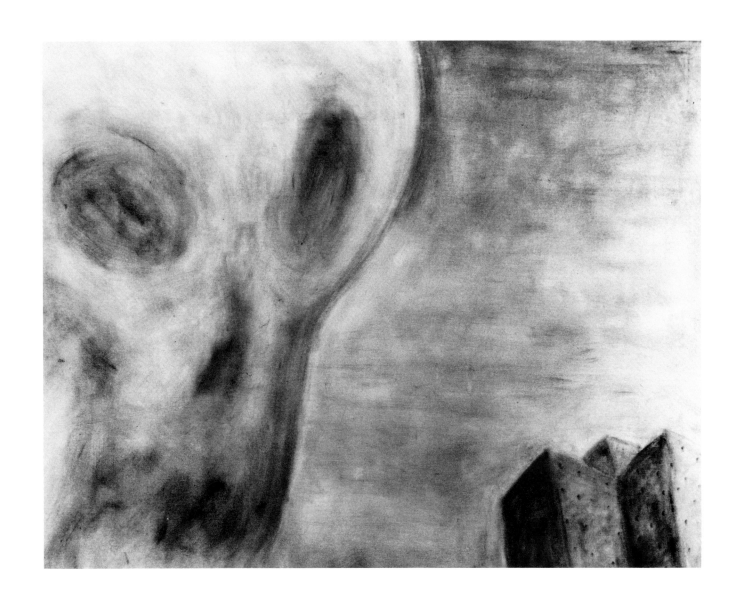

17. DANA GARRETT
Welcome, 1982
Acrylic on canvas, 48 x 96 inches
Courtesy of Tracey Garet / Michael Kohn Gallery, New York

exist among a multitude of other elements. Indeed, Fichter has developed a cast of "critters" or alter-egos that he deploys in his drawings, paintings, prints, and photographs. Among them are Mr. and Ms. Bones, Mutant Mule, Fish-Out-Of-Water, Baby Gene Pool and Mr. Bass. Characterized by Robert Sobieszek as the "Lone Cowboy of the Apocalypse," Fichter confronts the issue of survival in a post-nuclear world in a series of cibachrome still-lifes entitled *Apocalyptic Visions*.[51]

Like Schlattman, Fichter works with contrived and constructed setups, but ones devoid of any direct human presence. In *Apocalyptic Visions*, 1982, working from a *horror vacui* aesthetic, Fichter presents a terrifyingly beautiful juxtaposition of images. In *Bass D-Zaster*, Fichter constructs a background of fish out of water, piled atop one another, their gaping mouths containing toy soldiers and cowboys, as well as supporting two toy plastic skeletons (fig. 18). The fish's natural habitat is presented in a print of the "American Maelstrom," a scene of disaster as three ships are sucked into a turbulent whirlpool. The presence of a plastic astronaut seems to suggest that our only hope of survival is in outer space, implying that earth's delicate ecological balance is out of kilter and beyond control. And in *Waiting for the Signal,* the composition is dominated by a winged rabbit, a mutant existing in a post-nuclear world.

Whereas the animals pictured in Fichter's photographs are either dead or mutant survivors, the animals in Melissa Miller's paintings anticipate a vague but clearly impending threat. For both Miller and Fichter, animals stand in for more primitive and innocent humans. (In Fichter's work, some of their names, such as Mr. Bass, are clearly anthropomorphized.) In Miller's paintings, they at once represent a connection with nature, yet, like us, are subject to its more violent manifestations. In *Against the Wind*, 1981, two bright red foxes advance against powerful winds, both attempting to use their sense of smell to gauge the danger ahead (fig. 19). The threat of an imminent storm of devastating proportions materializes in a series of paintings on paper, *Studies for the*

Ark, 1981. In one study of coyotes and roadrunners, the terrified animals flee in all directions from a cyclone-like funnel of wind.

The buffeting winds, deluges, and impending threats in Miller's paintings represent a personal apocalypse. As with Stikas and Oji, the depiction of natural forces out of control correlates with a time of change and struggle for the artist. Miller has indicated that the series was executed during a time of illness and death in the family. These, and other anxieties then surface albeit in the apprehensive subject matter of the work.[52]

The heightened color and agitated brushstroke that formally convey an impression of turbulence and anxiety in Miller's work serve a similar purpose in Katherine Porter's paintings. But unlike Miller, Porter relies almost totally on abstract forms to communicate her vision. In *The Sun is Black in Yellow Night*, 1983, a vestigial grid around the borders (an important element in earlier work) seems to barely contain the "sun" that looks more like a cog spinning out of control, sending off sparks (fig. 20). The darkened division sharply bisects the composition diagonally, and also encloses the tangled red "barbed wire," and spear-like extrusions which appear to pierce the sun.

Porter notes: "My paintings are about chaos, constant changes, opposites, clashes, big moments in history," including both the personal and the political.[53] And critic Jonathan Fineberg explains, "Her wish to convey her political and social concerns through her paintings is persistent; she leaves no doubt that the explosive energy in her paintings is related to emotions like her compassion for the suffering and political oppression of people of El Salvador and her anxiety over the ecological risks of nuclear power."[54] The title for *The Sun is Black* is taken directly from the *Revelation* of St. John, and both reflect a more generalized mood of anxiety and the specific concerns of an ecological disaster, where, because of increasing pollution, the sun would actually appear black against a smog-filled, yellow sky.

Porter here refers to the Biblical passage as a general al-

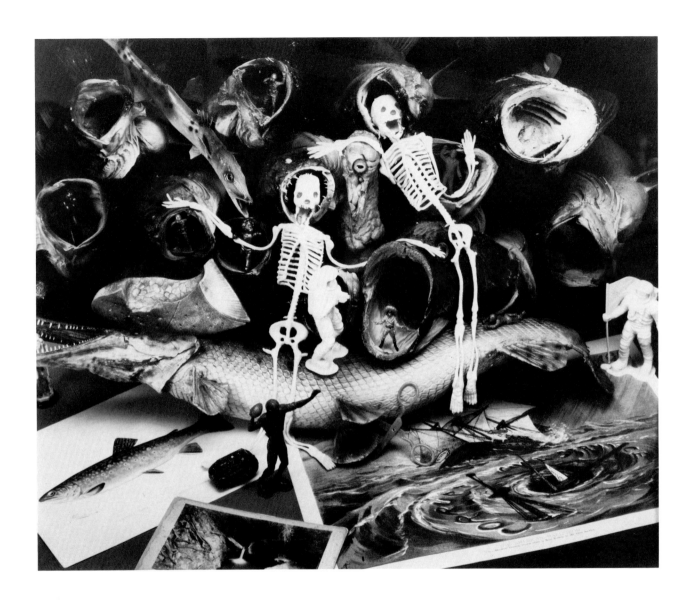

18. ROBERT FICHTER
 Bass D-Zaster, from *Apocalyptic Visions,* 1982
 Cibachrome print, 30 x 40 inches
 Courtesy of Friedus/Ordover Gallery, New York

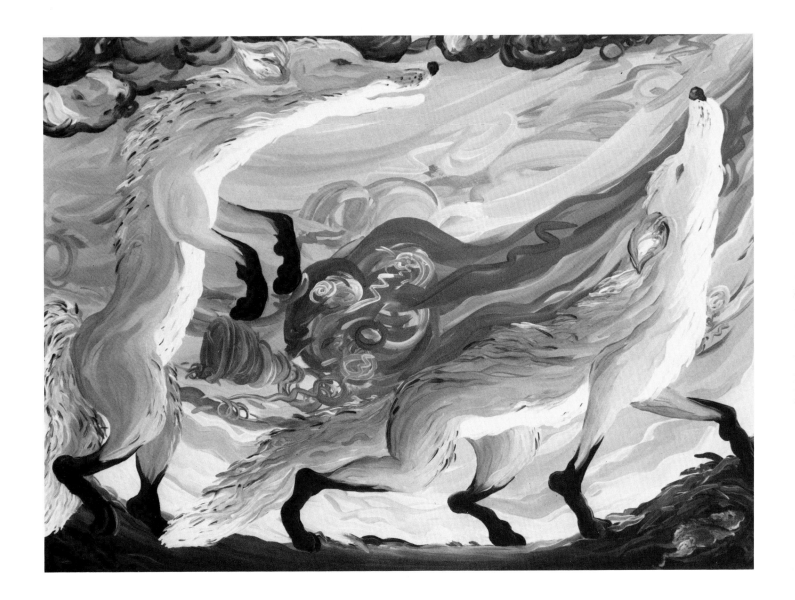

19. MELISSA MILLER
Against the Wind, 1981
Oil on canvas, 36 x 40 inches
Collection of Robert Butler and Sonny Burt, Dallas, Texas

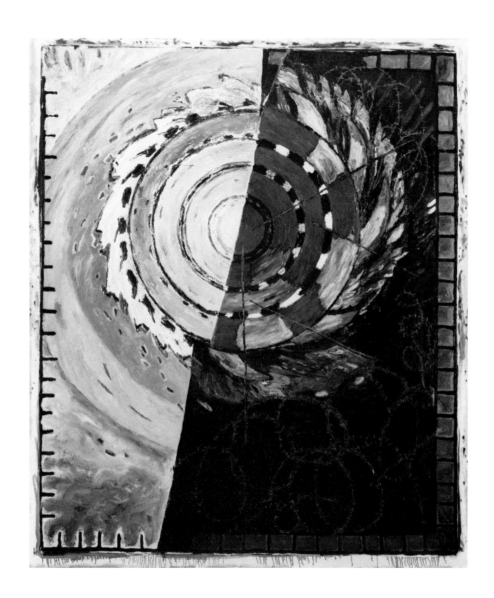

20. KATHERINE PORTER
The Sun is Black in Yellow Night, 1983
Oil on canvas, 92 x 79 inches
Courtesy of David McKee Gallery, New York

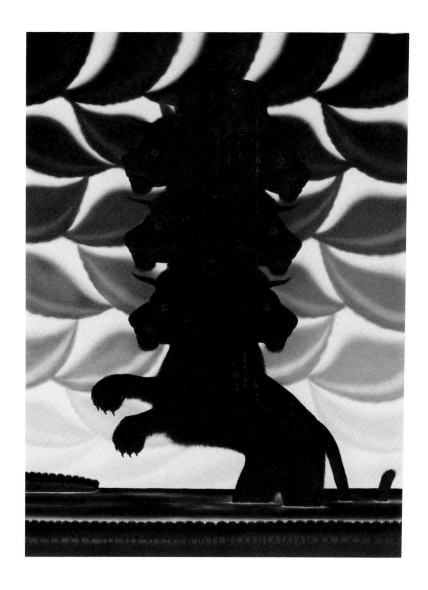

21. ROGER BROWN
 The Beast Rising from the Sea, 1983
 Oil on canvas, 72 x 54 inches
 Collection of the artist

legory for potential catastrophe much in the way that Roger Brown and Robert Younger do. The fantastic imagery of the *Revelation* attracts Brown, who has as part of a Biblical series, depicted the seven-headed monster with ten horns (13:1-2) in *The Beast Rising from the Sea,* 1983 (fig. 21). Likewise, the blocky, simplified features of Younger's monumental sculptural installation, recalling Easter Island heads, bears the numbers 666, the "mark of the beast," i.e. the Anti-Christ *(Revelation* 13:18), an omen of terror among Christian fundamentalists (fig. 22).

But whereas these artists refer to St. John's *Revelation* without necessarily believing its prophesies (indeed Katherine Porter maintains that she doesn't believe in an apocalypse *per se,* and while "sometimes my work is catastrophic, I don't feel pessimistic")[56] the Reverend Howard Finster fervently confirms a coming apocalypse. A self-taught artist and minister, Finster began constructing an ongoing, monumental environment entitled *Paradise Garden* in 1961, and started painting in 1976. The central theme underlying the work is apocalyptic, bearing a "message about last things: the paradox of our possible salvation or ultimate destruction by technology, and the coming millenium in the atomic age."[57] In *Love and Death Meet Together,* 1981, a central image of a snake constricting the world is surrounded by Finster's writings predicting various pitfalls, doomsdays, and roads to salvation (fig. 23). Finster considers himself a prophet, in his words, "one of the world's last red lights," and his observations include a panoramic vision of the evils of contemporary culture and modern life, as well as a more cosmic view of another planetary existence.

In another vein, and from a totally different vantage point, Rudolf Baranik also speculates about the state of contemporary culture. Some of his observations currently take the form of dictionary entries from the 24th century – looking back, somewhat ironically, at obsolete and archaic concepts to which we currently adhere (fig. 24). For example, in defining the world, Baranik describes the concept of the universe as "limited as late as the 22nd century to the segments of visible phenomena resembling the solar system such as galaxies," thus implying a future view of the world as encompassing more than visible material phenomena. The "end of the world" is defined as a notion equal to the creation of the world and involving the "sense of fear which arose in the last decades of the 20th century." Baranik ascribes the fear to the developments of "members of the mass-killing profession, known as the *Military* (obsolete) united with other retarded groups, technicians and members of governments (archaic) in planning to use primitive nuclear knowledge in creating implements of mass-death." These references to concepts and ideas held in what is described as "pre-civilization era" hold forth the hope that the world will survive, indeed, evolve for the better, despite childish and ludicrous acts of the powerful "retardees" composed of American and Soviet "military, technicians, and members of government," hence the necessity of the dictionary to define the archaic concepts.

· · · · ·

The notion of artist as prophet has undergone various transformations throughout history including the Greek concept of a form of "possession" by some divine force outside the artist. The Reverend Howard Finster's visions return us to this idea of the artist as "seer," "acting through his art as a channel for a divine message not his own."[58] A tendency still lingers to view artists as possessing prophet-like powers, and Kandinsky's depictions of stylized cannons in his paintings from the 1910s are now viewed as precognitions of World War I. Indeed, Kandinsky, according to one interpretation, viewed himself as a "prophet atop the mystical social triangle...[pointing] the way to the promised land of the Great Spiritual."[59] Whether artists are divinely inspired or delving into unconscious or subconscious depths of their psyches, they clearly respond to the prevailing moods of the times.

That artists today, among others, are sensing a "doomsday" undercurrent is evident in the work included in this exhibition. Indeed the current malaise has been likened to earlier outbreaks of millenarianism. And com-

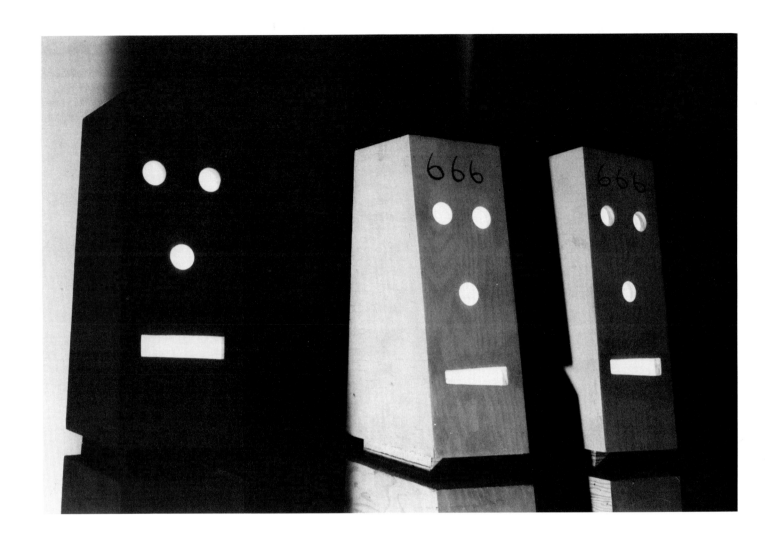

22. ROBERT YOUNGER
 Maquettes for *Revelation 13-18*, 1983
 Collection of the artist

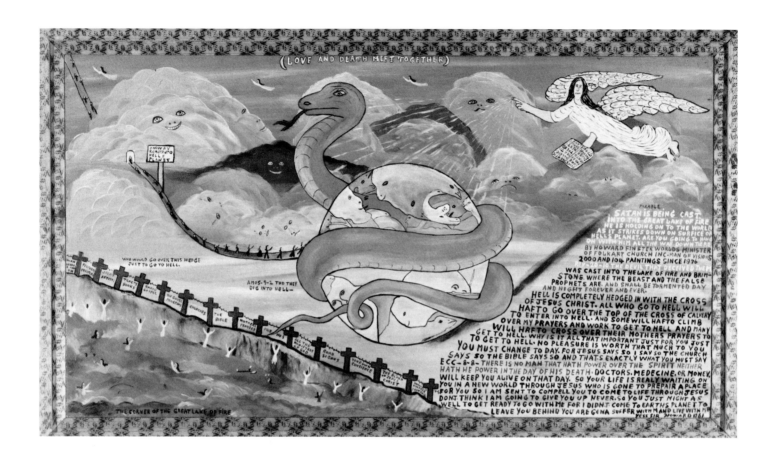

23. REVEREND HOWARD FINSTER
 Love and Death Meet Together, 1981
 Enamel on wood, 23½ x 40¾ inches
 Collection of Patrick and Gwen Rodriguez, Chicago, Illinois

W O R L D 1. <u>The totality of phenomena</u>. 2. <u>The universe</u> (a concept limited as late as the 22nd century to the segments of visible phenomena resembling the solar system, such as the galaxies.) 3. <u>The earth and the human inhabitants collectively</u>. Though regarded as archaic in contemporary logic-language, the term is not considered obsolete in the telepathic literature of the present.

W O R L D , T H E C R E A T I O N O F . A concept of the pre-comprehension of existence era (- 23rd century), held equally in religious (archaic) and secular (obsolete) thinking. Remaining archaic documentation records in video, diapositives, microfilm and laser prints show that in the late stages of the primitive era astronomers (obsolete) were in the forefront of what was considered scientific research about creation.

W O R L D , T H E E N D O F . 1. A concept held in the pre-existence comprehension era as co-equal with the <u>Creation of the world</u> (archaic).

W O R L D , T H E E N D O F . 2. <u>A sense of fear</u> which arose in the last decades of the 20th century among the more civilized segments of the earth's population when the members of the mass-killing profession, known as the <u>military</u> (obsolete) united with other retarded groups, technicians and members of governments (archaic) in planning to use primitive nuclear knowledge in creating implements for mass-death. The retardees were powerful in the late North American Empire, where they reigned in a five-faceted building on the Potomac and in the Empire of the Eurasian continent.

W O R L D , T H E E N D O F . 3. The title of an axhibition held during the 8th decade of the 20th century in New York, the most populous city of the late North American empire, in <u>the New Museum</u>, one of the last traditional museums (archaic) of the pre-civilization era.

24. RUDOLF BARANIK
 Study for *Finisterre: Dictionary and Manifesto,* 1983
 Photostat, 7¼ x 6¼ inches
 Collection of the artist

parisons with the apocalyptic atmosphere prevalent in the Middle Ages would seem appropriate when the Acquired Immune Deficiency Syndrome (AIDS) is discussed in relation to the Black Death.[60] Yet the tenor of the response to a contemporary threat of annihilation differs distinctly from earlier manifestations. The most obvious difference between the medieval and contemporary apocalyptic mentalities is that with the former, the cataclysm was thought to usher in a new golden age which would transform life on earth. The optimistic anticipation of an earthly paradise that would accompany the anxiously awaited apocalypse contrasts sharply with a current sense of pessimism and gloom. Christopher Lasch discusses a "waning sense of historical time…in particular, the erosion of any strong concern for posterity" as part of the spiritual crisis of the '70s and which is distinguishable from earlier millenarian outbreaks.[61]

Thus, the end of the world engenders a wide variety of responses, including hope, terror, and apathy. Susan Sontag compares the response of the Eastern European Jews in the seventeenth century, who upon hearing the news of a messiah on earth and an imminent end to the world abandoned their homes and businesses and fled to Palestine, to the response of the Berliners, who, upon learning in 1945 that Hitler had decided to kill them all, reacted without great agitation.[62]

Clearly, the knowledge of the mammoth force of nuclear power and the detonations at Hiroshima and Nagasaki have added a new dimension to potential endings of the world. Sontag also comments on the age-old theme of good versus evil, which constitutes a vital component of the idea of the apocalypse. In science fiction the battle of light and darkness continues with a new grimness, due in part to a greater visual credibility and added complexity. Pure innocence doesn't exist any more and "modern historical reality has greatly enlarged the imagination of disaster."[63]

Similarly, the response to the knowledge of a possible nuclear annihilation has evolved significantly since 1946. The general apathy of the '70s seems to have given way to a burst of energy in the early '80s, signified by Schell's timely publication of *The Fate of the Earth,* and Ground Zero week in 1982, comprised of mass marches and national and world-wide activities. And both the awareness and impact of a potential nuclear holocaust differ greatly among the various segments of the U.S. population. For those who were adults in the 1940s, the atomic bomb was a great shock; the immense horror mixed with relief at the news of the end of the war. Children in the '50s knew only of a world whose total destruction was possible through atomic warfare, the only hope for survival existing in the form of bomb shelters. That was an era of drills and fears captured recently in the film *Atomic Cafe.* And for those growing up in the '60s and the early '70s, the threat of nuclear destruction was a less visible undercurrent, due in part to détente, but for whom the apocalypse was transformed into a faraway and drawn out, though highly destructive war of "conventional" arms in Vietnam.

The psychological effects of the threat of nuclear annihilation are only beginning to be assessed. Robert Jay Lifton, who has studied the survivors of Hiroshima, notes that "since World War II, we've been living a double life in the sense of knowing that something close to extinction is possible very quickly and very suddenly, while on the other hand going about business as usual…we've been suppressing or numbing ourselves to that image – although it hasn't been totally absent from our minds – and have developed a pattern of resignation adaptation in a world with the bomb."[64]

Hans Magnus Enzensberger, a contemporary German poet and essayist, in "Two Notes on the End of the World," likens the apocalypse to a commodity, assigning it to part of our ideological baggage, and describing it as a second reality.[65] He too distinguishes the current notion of the end of the world from older versions, since before "it was a venerable and sacred idea," whereas today we are haunted by a secularized phenomenon. He continues:

The apocalypse was also once a singular event, to be expected unannounced as a bolt from the blue: an unthinkable moment

that only seers and prophets could anticipate – and, of course, no one wanted to listen to their warnings and predictions. Our end of the world, on the other hand, is sung from the rooftops even by the sparrows; the element of surprise is missing; it seems only to be a question of time. The doom we picture for ourselves is insidiously and torturingly slow in its approach, the apocalypse in slow motion."[66]

The contemporary seer is a repulsively fat Dr. Strangelove, who "informs us that the atmospheric ozone belt will have disappeared in twenty years so that we shall surely be toasted by cosmic radiation if we are lucky enough to survive until then; unknown substances in our milk are driving us to psychosis; and at the rate at which the world population is growing, there will soon be standing room only on our planet."[67]

Whether we are indeed in the midst of an ongoing apocalypse, or if the end is still to come, the arts are unavoidably affected. Jonathan Schell notes that in a nuclear world, artists who had once feared that their work might be found wanting by posterity now face the possibility that even "timeless masterpieces will fall into oblivion... because there will be no posterity."[68] He goes on to cite Harold Rosenberg's "de-definition of art," attributing the focus on the act of creation rather than the final product in part to art's independence from a world which assumes the existence of the human future.[69]

Whereas it might be going too far to liken art from that period to a self-fulfilling "sexual act that is isolated from the past," it does not seem unreasonable to associate what has been termed the "dematerialization of art" in the early '70s with an increasing sense of the world's imminent end. The emphasis therefore on ephemeral art events, which existed only afterwards in documentation, seems to be as appropriate a response as any to a very uncertain world.

Peter Schjeldahl, in a 1978 article entitled the "Hydrogen Jukebox," characterizes the "long term toxic effects [on art] of the atom bomb terror of the last three decades" as a principal cause for a widespread disarray and morbidity of the arts in Western civilization. He analyzes the recent movements in light of a "no future" and "no past" effect, including Pop art with its "sensation of everything being simultaneously available and equally meaningful/meaningless."[70] Minimalism, on the other hand, he ascribes to the "no future effect" as being totally self-sufficient. Within his critical evaluation of the state of the arts, Schjeldahl allows for hope for the future, commenting positively on strong autobiographical and biographical prose and poetry, a renewed interest in craft and the short-lived tendency towards decorative and realist painting, "following the collapse of the modernist pieties (and anti-pieties) of the art object."[71]

In a more recent article, Carter Ratcliff describes the narrative trend in painting as anti-apocalyptic in intent, since the apocalypse implies an end to history and to the assumption that one event follows another. Denouncing the definition of "post-modernist" as that which ignores "all but the most reductive, most fervently anti-temporal sorts of recent art," Ratcliff argues for a redefinition of modernism that acknowledges its narrative aspects. Ratcliff goes on to discuss a number of artists whose work is narrative, including in his discussions the scenes of urban disasters of Roger Brown and Richard Bosman.[72]

Indeed, *The End of the World* includes a good number of works that tell a story, and in this case, an apocalyptic one. And it is indeed feasible that narrative art contradicts Schjeldahl's "no future" effect by implying a series of events. However, as is the case with the Reverend Howard Finster, the story that is told is one with a final ending. Michael Smith's installation depicts the banality of everyday life yet captures the underlying and constant threat of nuclear annihilation, whereas Bruce Charlesworth's narrative in *Projectile* portrays a heightened, intensified story with a mysterious and cataclysmic ending. And Beverly Naidus invents a conversation of two survivors, isolated in a primitive shelter which contains hints of what once was.

As discussed earlier, much of the narrative work included in this exhibition concerns itself with scenes of natural disasters. Like the apocalypse, the theme of

human struggle against the powers of nature is age-old, and thus the work of James Poag, Helen Oji, Linda Burgess, and Frank Gohlke can be viewed in this context. Interestingly, the artist Walter De Maria commented on the importance of natural disasters, noting that he "liked" them and thought that they might be the "highest form of art possible to experience…"[73] Similarly, Katherine Porter has remarked on her fascination with the tornadoes she experienced as a child. It is this enormous amount of energy that occurs with various forms of natural disasters and the concurrent disruption of the routine of our daily lives that triggers chilliastic fears.

And as we have seen, a number of contemporary artists have been inspired by the visions of doom heralded in St. John's *Revelation*. Whereas Reverend Howard Finster believes in the prophesies of a devastating end of the world, Katherine Porter, Roger Brown, and Robert Younger have used the speculative visions in a more personal way. Porter extracted a passage from the *Revelation* that conveys her belief in possible ecological dangers, whereas Brown depicted another passage as one of an ongoing Biblical series. And Younger found in the *Revelation* a connection with the monumental heads he has been working on.

Other artists have developed personal symbols to allegorically convey the idea of the end of the world. Dana Garrett's deserted cities and skeletons present an eschatological vision of mass death, and the animals in Melissa Miller's paintings are innocent bystanders to nature's powerful forces. On the other hand, a number of artists have tackled the specific threat of nuclear holocaust as one vision of the end. Donald Lipski has transformed the obsolete remains and leftovers of our technological society into his own quirky visions of the bomb, and Robert Morris has combined text and abstract image to convey some of the horrific side effects of a nuclear blast.

Some, although not all, of the artists who deal more directly with atomic subject matter, often do so from a political viewpoint. Robert Morris, Nancy Spero, and Rudolf Baranik share an antipathy towards nuclear armament. And it is interesting to note that outbreaks of millenarianism and apocalyptic yearnings are often accompanied by traumatic political and social upheavals. For example, in the Middle Ages, "the desire of the poor to improve the material conditions of their lives became transfused with phantasies of a world reborn into innocence through a final, apocalyptic massacre." In this vein, historian Norman Cohn sees in medieval millenarian movements precursors of the revolutionary movements of this century.[74] Depictions of war in general carry apocalyptic suggestions, which take on even greater relevance in a nuclear age.

Amidst the doom and gloom, certain artists turn to humor as a subversive means to treat a normally grim subject matter. Louie Grenier, Craig Schlattman, and Michael Smith, as well as to a certain degree, Helen Oji, all use a form of black humor. Schlattman's crazy homespun physicists and Grenier's delirious survivor function in an absurd world of mixed up values.

Finally, a number of artists included in this exhibition have dealt with the contradictions inherent in apocalyptic visions. In Michael Cook's videotape, government film footage of spectacularly beautiful atomic blasts is accompanied by a Gregorian-like chant about radiation. And Katherine Porter, Marianne Stikas, and Robert Fichter have all created lush images that also pertain to destruction. The apparent contradiction of that which is simultaneously beautiful and horrific provides fertile ground for artists.

And as Rudolf Baranik has noted, with the concept of the end of the world, "thinking makes a sharp turn and whistles in the dark."[75] How can we speculate on what we have never experienced, to think the unthinkable? Perhaps, as Peter Schjeldahl observes, it is the fact that artists mirror the debacle, and willingly confront the disagreeable, that allows art to function as a viable form of expression amidst the increasing pessimism and gloom.[76] Although the artists included here do not all necessarily

predict an apocalypse *per se,* all have used imagery to convey issues related to upheaval and change of some kind. With their visualization of the apocalypse, we are confronted with issues we would rather avoid. It is exactly the increasing number of those who are dealing with this subject matter that provides us with the hope for the future and no longer allows us to suppress and avoid the issues of our own and the earth's survival.

Lynn Gumpert

NOTES

1. Eleanor Heartney, "A Vision of Hell," *New Art Examiner,* vol. 10, no. 6, March 1983, p. 1.
2. Christopher Lasch, *The Culture of Narcissism: American Life in an Age of Diminishing Expectations* (New York: Warner Books, 1979, 1980), p. 3.
3. Ibid., p. xv.
4. Jonathan Schell, *The Fate of the Earth* (New York: Avon Books, 1982).
5. Harrison E. Salisbury, ibid. The only other article uninterrupted by cartoons, and also published in its entirety in one issue, was John Hershey's *Hiroshima.*
6. Schell, *Fate of the Earth,* p. 8. Here Schell cites Dr. Robert Jay Lifton, author of pioneering studies on the psychology of the nuclear predicament. In other words, we tend to avoid dealing with the horror of a nuclear holocaust and subsequent "immersion in death," but in so doing, fail to do anything to prevent it.
7. Reinhold Heller, "Kandinsky and Traditions Apocalyptic," *Art Journal,* vol. 43, no. 1, Spring 1983, pp. 19-20.
8. Hans Magnus Enzensberger, *Critical Essays* (New York: The Continuum Publishing Company, 1982), p. 233.
9. W. Warren Wagar, *Terminal Visions: The Literature of Last Things* (Bloomington: Indiana University Press, 1982), p. 4.
10. Hal Lindsey, *The Late Great Planet Earth* (Grand Rapids, Michigan: Zondervan, 1980, first ed.; New York: Bantam Books, 1973, 1981). The marketability of biblical prophecy led the *New York Times* to name Lindsey the best-selling author of the 1970s. Furthermore, this book was also made into a film in 1977, narrated by Orson Welles (William Martin, "Waiting for the End," *Atlantic Monthly,* vol. 249, no. 6, June 1982, p. 310).
11. Bruce Barone, "Introduction," *William Blake: The Apocalyptic Vision* (Purchase, New York: Manhattanville College, 1984).
12. See Heller, "Kandinsky and Traditions Apocalyptic." In this informative article, Heller briefly traces the recent scholarship on the importance of the apocalyptic for Kandinsky, and then places his interest in a wider cultural and historical context.
13. Fred Hoffman, *The Art and Life of Mark Tobey: A Contribution Toward the Understanding of a Psychology of Consciousness,* unpublished Ph.D. dissertation, University of California, Los Angeles, 1977, pp. 193-94. Hoffman, in Chapter 3, goes into length in analyzing the mural study and Tobey's understanding of St. John's *Revelation.*
14. Kenneth Clark, *Leonardo da Vinci* (Baltimore: Penguin Books, 1963), p. 149.
15. James Cornell, *The Great International Disaster Book* (New York: Charles Scribner & Sons, 1976), p. 1.
16. In telephone conversation with the author, August 1983.
17. Tony Schwartz, "What's Wrong With Local TV News?," *New York Times,* Sunday, March 7, 1982, Section 2, p. 230.
18. Andree Conrad, "Beyond the Panic Principle: Disaster and the American Imagination," *Book Forum,* vol. 21, no. 1, 1978, pp. 209-11.
19. *Projectile* was Charlesworth's contribution to *The Anxious Edge: Eight Artists,* Walker Art Center, Minneapolis, April 25–June 13, 1982, Lisa Lyons, Curator.
20. Charlesworth, letter to the author, August 21, 1983.
21. Mitchell Douglas Kahan, "Roger Brown and the American Scene," in *Roger Brown* (Montgomery, Alabama: Montgomery Museum of Fine Arts, 1980), p. 17.
22. Conrad, "Beyond the Panic Principle," p. 217. The seven stages currently used to describe reactions to natural catastrophe: 1) warning, 2) threat, 3) impact, 4) inventory, 5) rescue, 6) remedy, and 7) recovery.

23. Telephone conversation with the author, August 1983.
24. For a brief bibliography, see Wagar, *Terminal Visions,* p. 4 and notes 4-6.
25. The installation was held at Nexus Gallery, Philadelphia, from December 6-25, 1977.
26. Gordon Rattray Taylor, *The Doomsday Book* (New York: The World Publishing Company, 1970), pp. 72-77.
27. Jeanne Silverthorne, "Robert Younger: Nexus Gallery," *Arts Exchange,* March/April 1978, pp. 32-33.
28. Ibid., p. 33.
29. Schell, *Fate of the Earth,* p. 100.
30. Susan Sontag, "The Imagination of Disaster," in *Against Interpretation* (New York: Delta, 1966), p. 218.
31. Ibid., p. 204.
32. Wade Greene, "Rethinking the Unthinkable," *New York Times* Sunday Magazine, March 15, 1981, p. 45.
33. Nancy Spero in interview with Kate Horsfield, *Profile,* vol. 3, no. 1, January 1983, p. 6.
34. Spero delivered a paper on the medieval nun at the 1975 College Art Association conference. She also wrote the article, "Ende," *Women's Studies* [Great Britain], vol. 6, 1978, pp. 3-11.
35. Spero quoted in Lawrence Alloway, "Nancy Spero," *Artforum,* vol. 14, no. 9, May 1976, pp. 52-53.
36. *Government Approved Home Fallout Shelter Snack Bar* was first shown at Castelli Graphics, New York, May 10–
June 30, 1983.
37. Lasch, *Culture of Narcissism,* p. 4.
38. Federal Emergency Management Agency handout, (H-12-D), April 1980.
39. *This is Not a Test* was a first shown at Anna Leonowens Gallery of the Nova Scotia College of Art and Design, Halifax, April 3-8, 1978.
40. Unpublished statement by the artist.
41. Ibid.
42. Schell, *Fate of the Earth,* pp. 17-19.
43. *Unforgettable Fire,* Japanese Broadcasting Corporation, ed. (New York: Pantheon Books, 1977), pp. 7-8.
44. Schell, *Fate of the Earth,* pp. 9-10.
45. This connection between the alchemical and the atomic was also made in the Mabou Mines' *Dead End Kids,* a theatrical/performance piece.
46. Sontag, "The Imagination of Disaster," pp. 217-18.
47. Schell, *Fate of the Earth,* pp. 100-01.
48. Ibid., pp. 101-03.
49. Ibid., p. 76.
50. Michael Kohn, "Dana Garrett: L'Art Noir," *Arts Magazine,* vol. 56, April 1982, p. 120.
51. Robert Sobieszek, *Robert Fichter: Photographs and Other Questions* (Albuquerque: University of New Mexico Press, 1983).
52. Telephone conversation with the author, August 1983.
53. Katherine Porter in "Expressionism Today: An Artists' Symposium," *Art in America,* vol. 70, no. 11, December 1982, p. 73.
54. Jonathan Fineberg, "The Sensuality of Justice," in *Katherine Porter, Paintings 1981–1982* (New York: David McKee Gallery, 1982).
55. Martin, "Waiting for the End," p. 32.
56. Porter, "Expressionism Today: An Artists' Symposium," p. 73.
57. Jesse Murry, "Currents:Reverend Howard Finster," (exh. brochure, The New Museum, August 7–September 22, 1982).
58. Harold Osborne, *Aesthetics and Art Theory* (New York: E.P. Dutton, 1980), pp. 194, 201.
59. Heller, "Kandinsky and Traditions Apocalyptic," p. 25.
60. Michael Daly, "AIDS Anxiety," *New York,* vol. 17, no. 25, June 20, 1983, cover and p. 24.
61. Lasch, *Culture of Narcissism,* p. 5.
62. Sontag, "The Imagination of Disaster," p. 224.
63. Ibid., p. 215.
64. Lifton, cited in Wade Greene, "Rethinking the Unthinkable," p. 68.
65. Enzensberger, *Critical Essays,* p. 233.
66. Ibid., p. 234.
67. Ibid., pp. 234-35.
68. Schell, *Fate of the Earth,* p. 167.
69. Ibid., pp. 164-65.
70. Peter Schjeldahl, "The Hydrogen Jukebox: Terror, Narcissism…and Art," *Journal: The Los Angeles Institute for Contemporary Art,* no. 20, October/November 1978, p. 45.
71. Ibid.
72. Carter Ratcliff, "Narrative," *Print Collectors' Newsletter,* vol. XII, no. 6, January/February 1982, pp. 170-73.
73. Walter De Maria, "On the Importance of Natural Disasters," from *An Anthology,* La Monte Young, ed. (New York: Heiner Friedrich, 1970).
74. Norman Cohn, *The Pursuit of the Millenium* (New York: Oxford University Press, 1976, revised and expanded edition), p. 16. The subtitle offers a further explanation: "Revolutionary Millenarians and Mystical Anarchists of the Middle Ages."
75. Rudolf Baranik, artist's statement, p. 48.
76. Schjeldahl, "The Hydrogen Jukebox," p. 45.

WORKS IN THE EXHIBITION

Height precedes width precedes depth

RUDOLF BARANIK
Finisterre: Dictionary and Manifesto, 1983
Diptych: acrylic on canvas and oil and
graphite on canvas, 92 x 70 inches each
Collection of the artist

RICHARD BOSMAN
Panic, 1982
Oil on canvas, 79 x 108 inches
Collection of Robert H. Helmick,
Des Moines, Iowa

ROGER BROWN
Ablaze and Ajar, 1972
Oil on canvas, 70⅝ x 46¼ inches
Collection of Bernard and Ruth Nath,
Highland Park, Illinois

Sudden Avalanche, 1972
Oil on canvas, 72 x 48 inches
Jones/Faulkner Collection,
Chicago, Illinois

The Beast Rising from the Sea, 1983
Oil on canvas, 72 x 54 inches
Collection of the artist

LINDA BURGESS
Exploding House, 1980
Oil and craypas on paper mounted on
canvas, 30 x 20 inches
Collection of the artist

Night Tornado, 1980
Oil and craypas on paper mounted on
canvas, 42 x 53 inches
Collection of the artist

Impending Storm, 1981
Oil and craypas on paper mounted on
canvas, 42 x 35 inches
Collection of the artist

BRUCE CHARLESWORTH
Excerpt from *Projectile,* 1982
Installation: wood, paint and audiotape,
dimensions variable
Collection of the artist

Projectile, 1982
Color videotape with sound; 18 minutes
Collection of the artist

Untitled, 1983
Four cibachrome prints, 28¼ x 28¼ inches
each
Collection of the artist

MICHAEL COOK
Ashes, 1982
Oil on canvas, 72 x 72 inches
Collection of the artist

Work Completed, 1983
Oil on canvas, 72 x 72 inches
Collection of the artist

Radiation Remains the Same, 1980–81
Color videotape; 4 minutes, 5 seconds
Collection of the artist

ROBERT FICHTER
Bass D-Zaster, from
Apocalyptic Visions, 1982
Cibachrome print, 30 x 40 inches
Courtesy of Friedus/Ordover Gallery,
New York

Lassie Puzzle, from
Apocalyptic Visions, 1982
Cibachrome print, 30 x 40 inches
Courtesy of Friedus/Ordover Gallery,
New York

Waiting for the Signal, from
Apocalyptic Visions, 1982
Cibachrome print, 30 x 40 inches
Courtesy of Friedus/Ordover Gallery,
New York

REVEREND HOWARD FINSTER
Love and Death Meet Together, 1981
Enamel on wood, 23½ x 40¾ inches
Collection of Patrick and
Gwen Rodriguez, Chicago, Illinois

*The Beginning of the Mysteries of
a Great Work,* 1983
Mixed media, 27¾ x 20¼ x 3¾ inches
Courtesy of Phyllis Kind Gallery,
New York

DANA GARRETT
Welcome, 1982
Acrylic on canvas, 48 x 96 inches
Courtesy of Tracey Garet/
Michael Kohn Gallery, New York

Run, 1983
Oil on paper, 81½ x 42½ inches
Courtesy of Tracey Garet/
Michael Kohn Gallery, New York

FRANK GOHLKE
Aftermath: The Wichita Falls Tornado
series, 1979–80
"#3A, Southmoor Manor Apartments,
Looking North, April 14, 1979"
"#3B, Southmoor Manor Apartments,
Looking North, June 1980"
"#20A, Southwest Parkway near Fair-
way, Looking West, April 15, 1979"
"#20B, Southwest Parkway near Fair-
way, Looking West, June 1980"
"#12A, View of Faith Village from
Kiwanis Park, Looking East, April 14,
1979"
"#12B, View of Faith Village from
Kiwanis Park, Looking East, June 1980"
"#11A, 4503 McNeil, Looking North,
April 14, 1979"
"#11B, 4503 McNeil, Looking North,
June 1980"
Gelatin silver prints, 16 x 20 inches each
Collection of the artist

LOUIE GRENIER
Pass Debris, 1982
Color videotape with sound;
3 minutes, 42 seconds
Courtesy of Castelli-Sonnabend Tapes
and Films, New York

DONALD LIPSKI
Building Steam (#40), 1981
Vacuum cleaner, graphite paint, glass,
porcelain insulators, fork, Plasti-Dip and
plastic pellets, 17 x 40 x 16 inches
Courtesy of Germans Van Eck Gallery,
New York

Building Steam (#63), 1981
Demolition bomb, graphite paint, chalk,
stainless steel and NATO kilotonnage
calculators, 120 x 14 x 14 inches
Courtesy of Germans Van Eck Gallery,
New York

MELISSA MILLER
Against the Wind, 1981
Oil on canvas, 36 x 48 inches
Collection of Robert Butler and
Sonny Burt, Dallas, Texas

Studies for the Ark: Bears, 1981
Acrylic on paper, 22½ x 28⅜ inches
Courtesy of Texas Gallery, Houston and
Holly Solomon Gallery, New York

Studies for the Ark: Black Swan, 1981
Oil on paper, 22¾ x 28¾ inches
Collection of Barbara and Edward
Spevack, Huntington, New York

Studies for the Ark: Coyotes and Roadrunners,
1981
Acrylic on paper, 22½ x 28⅜ inches
Private Collection, Dallas

ROBERT MORRIS
Untitled (#10977), from
Firestorm series, 1982
Charcoal, ink and graphite on paper,
100 x 114 inches
Courtesy of Sonnabend Gallery, New York

BEVERLY NAIDUS
This is Not a Test, 1978–83
Installation: mixed media,
dimensions variable
Collection of the artist

HELEN OJI
Clouds of Stone (Volcano Series #42), 1983
Charcoal and acrylic on paper,
96 x 144 inches
Courtesy of Monique Knowlton Gallery,
New York

Earth Cracks (Volcano Series #41), 1983
Charcoal and acrylic on paper,
96 x 72 inches
Courtesy of Monique Knowlton Gallery,
New York

JAMES POAG
Two Buildings, 1982
Gesso, acrylic and litho crayon on paper,
38 x 50 inches
Collection of the artist

Plants Marching on the City, 1983
Gesso, acrylic and litho crayon on paper
mounted on canvas, 46½ x 62 inches
Collection of the artist

Storm, 1983
Gesso, acrylic and litho crayon on paper
mounted on canvas, 62 x 68½ inches
Collection of the artist

KATHERINE PORTER
The Sun is Black in Yellow Night, 1983
Oil on canvas, 92 x 79 inches
Courtesy of David McKee Gallery,
New York

CRAIG SCHLATTMAN
Energy Changes Matter Experiment, 1982
Type-C print, 20 x 24 inches
Collection of the artist

*Fission Experiment (Homage to
Oppenheimer); When a Neutron Collides with
a U-235 Particle, Fission Could Occur,* 1982
Type-C print, 20 x 24 inches
Collection of the artist

*Physical Laws Experiment; Testing E=mc²:
Starlight Bends According to Mass of
Object it Passes,* 1982
Type-C print, 20 x 24 inches
Collection of the artist

*Thermodynamics Experiment, Law I (Energy
Cannot Be Created or Destroyed, Only
Converted from One Form to Another),* 1982
Type-C print, 20 x 24 inches
Collection of the artist

MICHAEL SMITH with
ALAN HERMAN
*Government Approved Home Fallout Shelter
Snack Bar,* 1983
Installation: mixed media,
dimensions variable
Courtesy of Castelli Graphics, New York

NANCY SPERO
Bomb Proliferation, 1966
Gouache and ink on paper,
34 x 27¼ inches
Courtesy of Willard Gallery, New York

Bomb-Victims, 1966
Gouache and ink on paper,
27¼ x 34 inches
Courtesy of Willard Gallery, New York

Sperm Bomb, 1966
Gouache and ink on paper,
27½ x 33¾ inches
Courtesy of Willard Gallery, New York

Bomb, 1968
Gouache and ink on paper,
35½ x 23½ inches
Courtesy of Willard Gallery, New York

Bomb-Victims, 1968
Gouache and ink on paper,
38¼ x 24¾ inches
Courtesy of Willard Gallery, New York

MARIANNE STIKAS
End of the World with a Halo, 1982
Oil on canvas, 46 x 54 inches
Collection of the artist

Radioactive Landscape, 1982
Oil on canvas, 54 x 60 inches
Collection of the artist

ROBERT YOUNGER
Revelation 13-18, 1983
Installation: mixed media,
approximately 18 x 8 x 10 feet
Collection of the artist

RUDOLF BARANIK

ARTIST'S STATEMENT

Lands End and Finisterre are places on this earth. But when the ancient Britons and Bretons looked out at the dark ocean they defined more than geography: fear of the unknown and doubt about being are the same; whether, as in Rilke's "What will you do God, when I die?" defeat is conjured through beauty, or in the stench of burned flesh of heretics (they saw beauty in not fearing), the resistance is against not being, the fight to the end against the end. But—"The end of the world?" Here thinking makes a sharp turn and whistles in the dark. And it does so convincingly, because the End of the World is surely in today's language an expression of merriment: witness how it is used so often as a jolly foil— "It is not the end of the world." And if it were? If the end came it would be unrecognizable; nothing rooted in being can define not being. But we can see the end in a primitive way, as did the Celts on the seashore.

We can see the end in terms we understand. Formerly known as "war," mass-death has now latched on to nuclear power. Death does not play chess—it plays the bookkeeper of hundreds of millions. Political resistance, and art of resistance, can do nothing against the end. But it can act against mass-killing (former "modern war") against accepting premature mass-death as part of the world order.

Born in Lithuania, 1920. Attended the Art Institute of Chicago (1947), Art Students League, New York (1948), Academie Julian, Paris (1949), studied with Fernand Léger in Paris (1950–51). Lives in New York City.

SELECTED SOLO EXHIBITIONS

1950–Galerie Huit, Paris, France 1953–ACA Gallery, New York (also '55) 1958–Roko Gallery, New York (also '60, '61) 1963–Ball State University Museum, Muncie, IN 1968–Pratt Institute, New York 1969–*Ten Downtown* Loft Exhibition, New York 1973–New School for Social Research, New York; *Rudolf Baranik, Paintings and Collages*, Livingston College Gallery, Rutgers University, New Brunswick, NJ (exh. cat.; text by Daniel Newman) 1974–Lerner-Heller Gallery, New York (also '75, '76, '79, '81) 1977–*Napalm Elegy and Other Works*, Wright State University Gallery, Dayton, OH; Pelham-Von Stoffler Gallery, Houston, TX

SELECTED GROUP EXHIBITIONS

1954–*Recent Work by Young Americans*, Museum of Modern Art Traveling Exhibition, New York 1958–*American Painting*, Brooklyn Museum, New York; *Whitney Museum of American Art Annual*, Whitney Museum of American Art, New York 1959–*Selections from the Whitney Annual*, American Federation of Art Traveling Exhibition, New York 1960–*Contemporary Painting*, National Institute of Arts and Letters, New York; *Seventh Annual Exhibition*, University of Nebraska, Lincoln 1961–*New Acquisitions*, Whitney Museum of American Art, New York 1964–American Academy of Arts and Letters, New York; *One Hundred and Fifty-Ninth Annual Exhibition*, Pennsylvania Academy of the Fine Arts, Philadelphia 1967–*Collage of Indignation*, Loeb Student Center, New York University, New York 1968–*Artists and Writers Protest Against the War in Vietnam Portfolio Exhibition*, AAA Galleries, New York; *International Anti-War and Liberation Exhibition*, Nihon Gallery, Tokyo, Japan 1976–*American Concern: The Humanist View*, Moravian College, Bethlehem, PA 1977–*A Patriotic Show*, Wright State University Gallery, Dayton, OH 1980–*100 Artists/100 Years*, Art Institute of Chicago, IL 1981–*Art of Conscience: The Last Decade*, Wright State University Gallery, Dayton, OH (exh. cat.; text by Donald Kuspit; traveled); *Four Manifestos*, Lerner-Heller Gallery, New York; *Ikon/Logos*, The Alternative Museum, New York; *War Games*, Ronald Feldman Gallery, New York 1982–*Art Couples I*, Institute for Art and Urban Resources at P.S. 1, Long Island City, NY

SELECTED BIBLIOGRAPHY

Articles and Reviews

Battcock, Gregory. "Letter from New York," *Art and Artists* [London], vol. 8, no. 6, September 1973, pp. 3-4.
Davis, Douglas. "Post Post – Art II: Symbolismo, Come Home," *Village Voice*, August 13, 1979.

Evett, Kenneth. "Eros, Death and the Pastoral Scene," *The New Republic,* vol. 13, no. 170, March 30, 1974, pp. 30-31.

Frank, Peter. "A Patriotic Show," *New York Art Journal,* March 1977.

Kramer, Hilton. "Art Reviews: Baranik," *Arts Magazine,* February 1955.

Kuspit, Donald. "Art of Conscience," *Dialogue,* September/October 1980.

———. "Review," *Art in America,* vol. 68, no. 3, March 1980, p. 124.

———. "Rudolf Baranik's Uncanny Awakening from the Nightmare of History," *Arts Magazine,* vol. 50, no. 6, February 1976, p. 63.

Lippard, Lucy R. "Alcuni Manifesti Politici," *Data* [Milan], November/December 1975.

———. "Hot Potatoes: Art and Politics in 1980," *Block* [London], no. 4, 1981, p. 2.

Masheck, Joseph. "Reviews," *Artforum,* vol. 13, no. 8, April 1975, p. 85.

O'Hara, Frank. "Reviews: Baranik," *Art News,* vol. 53, no. 10, February 1955, p. 90.

Raynor, Vivien. "Rudolf Baranik," *Arts Magazine,* vol. 38, no. 2, November 1963.

Ries, Martin. "Interview with Rudolf Baranik," *Arts Magazine,* vol. 48, no. 5, February 1974.

Books

Ashton, Dore. *American Art Since 1945.* New York: Oxford University Press, 1982.

Lucie-Smith, Edward. *Art in the Seventies.* New York: Cornell University Press, 1980.

Sandler, Irving and Lawrence Alloway. *Rudolf Baranik – Napalm Elegy.* New Brunswick, NJ: Rutgers University, 1973.

Schwartz, Barry. *The New Humanism.* New York: Praeger Publishers, 1974.

Artist's Writings

"Art and Politics: An Exchange" [with Donald Kuspit], *Art in America,* vol. 63, no. 5, September/October 1975, p. 36.

"Art in Cuba," *Artforum,* vol. 21, no. 4, December 1982.

"A Socialist Formalist View on Berger and Fuller," *Art Monthly,* no. 60, October 1982, p. 26.

"A Statement," *Tracks,* vol. 2, no. 2, Spring 1976, p. 30.

"The Dialectic of Museums," *Artworkers News,* vol. 10, no. 8, April 1981, p. 16.

"Is the Alternative Space A True Alternative?" *Studio International,* vol. 195, no. 990, January 1980.

"Letters," *Artforum,* vol. 15, no. 1, September 1976, pp. 8-9.

"Letters," *Artforum,* vol. 16, no. 9, May 1978, p. 10.

"Letters," *New York Times,* Section 2, January 4, 1976.

"Make a Political Statement," *Art-Rite,* no. 6, Summer 1974, pp. 25, 81.

"The Nigger Drawings," *Art Monthly,* no. 29, March 1979, p. 27.

"Painter's Reply," *Artforum,* vol. 14, no. 1, September 1975, pp. 26-36.

"Predictable Impossible," *Artworkers News,* vol. 10, no. 10, June 1981, p. 28.

"The State of Formalism," *Art Criticism,* vol. 1, no. 3, p. 97.

"Statement on Public Monuments," *Appearances,* no. 9, 1983, p. 91.

"U.S./U.K. Dialogue on Social Purpose," *Artscribe* [London], no. 14, October 1978, p. 54.

RICHARD BOSMAN

ARTIST'S STATEMENT

When the gesture of the image matches the gesture of the paint the result is feeling. I want my paintings to be about that feeling. My work is not so much about murders, drownings, suicides or combat but about desperation, fear, hope, and resilience. They're about possibilities and consequences at the same time. For me my successful paintings are fractured; they have multiple levels of meaning, the literal image and a more complex psychological component. My image of a "Drowning Man" deals with a figure in literal trouble but it's also a metaphor for a swamped over-saturated subconscious. The victims in my paintings are symbols of everyday losses in our lives.

Born in Madras, India, 1944. Attended the Byam Shaw School of Painting & Drawing, London (1964–69); The New York Studio School, New York (1969–71); Skowhegan School of Painting and Sculpture, Skowhegan, Maine (1970). Lives in New York City.

SELECTED SOLO EXHIBITIONS

1981 – Brooke Alexander, Inc., New York (also '82, '83) 1982 – *Richard Bosman, Paintings & Woodcuts,* Dart Gallery, Chicago, IL; *Richard Bosman Prints,* Thomas Segal Gallery, Boston, MA; *Focus: Richard Bosman,* Fort Worth Art Museum, TX; *Woodcuts by Richard Bosman,* Cirrus Gallery, Los Angeles, CA 1983 – Mayor Gallery, London, England; Reconnaissance, Melbourne, Australia

SELECTED GROUP EXHIBITIONS

1975 – Mary Paz Gallery, Málaga, Spain

1977 – Hundred Acres Gallery, New York 1980 – *Illustration & Allegory,* Brooke Alexander, Inc., New York; *Selections,* The Drawing Center, New York; *The Times Square Show,* 201-5 West 41st Street, New York 1981 – *For Love and Money: Dealer's Choice,* Pratt Manhattan Center, New York; *Real Life Magazine Presents,* Nigel Greenwood, Inc., London, England; *Represent, Representation, Representative,* Brooke Alexander, Inc., New York; *Surfaces, Textures,* Summer Penthouse Exhibition, Museum of Modern Art, New York 1982 – *Awards in the Visual Arts,* National Museum of American Art, Washington, D.C. (traveled); *Beast: Animal Imagery in Recent Art,* Institute for Art and Urban Resources at P.S. 1, Long Island City, NY; *Block Prints,* Whitney Museum of American Art, New York; *Body Language: Figurative Aspects of Recent Art,* Hayden Gallery, Massachusetts Institute of Technology, Cambridge (traveled); *Fast,* Alexander F. Milliken, Inc., New York; *Focus on the Figure: 20 Years,* Whitney Museum of American Art, New York; *The Image Scavengers,* Institute of Contemporary Art, University of Pennsylvania, PA; *Large Paintings,* Brooke Alexander, Inc., New York; *New Figuration in America,* Milwaukee Art Museum, WI; *New York Now,* Kestner-Gesellschaft, Hannover, West Germany (traveled); *Projects, Artists's Books,* Museum of Modern Art, New York; *74th National Exhibition,* Art Institute of Chicago, IL 1983 – *The American Artist as Printmaker,* Brooklyn Museum, NY; *Black & White: A Print Survey,* Castelli Graphics, New York; *Prints from Blocks:* New York; *Back to the U.S.A.,* Kunstmuseum, Lucerne, Switzerland (traveled); *New York, New Work, Contemporary Painting from New York Galleries,* Delaware Art Museum, Wilmington; *New York Painting Today,* Carnegie-Mellon University, Pittsburgh, PA; *Intoxication,* Monique Knowlton Gallery, New York; *Self-Portraits,* Linda Farris Gallery, Seattle, WA

SELECTED BIBLIOGRAPHY

Articles and Reviews

Berlind, Robert. "Focus on the Figure: Twenty Years at the Whitney," *Art in America,* vol. 70, October, 1982.

Deitch, Jeffrey. "Report from Times Square," *Art in America,* vol. 68, no. 7, September 1980, pp. 58-63.

English, Christopher. "New Figuration from Old Milwaukee: Bosman serves up what's brewing in New York," *New Art Examiner,* January 1983.

Field, Richard S. "On Recent Woodcuts," *Print Collector's Newsletter,* vol. XIII, no. 1, March/April 1982, pp. 1-6.

Flood, Richard. "Richard Bosman," *Artforum,* vol. 20, January 1982, p. 80.

Glueck, Grace. "Richard Bosman," *New York Times,* Friday, March 25, 1983.

Goldman, Judith. "Woodcuts: A Revival," *Portfolio,* vol. 4, November/December 1982, pp. 66-71.

Kramer, Hilton. "Art: 'Illustration & Allegory' on View," *New York Times,* Friday, May 23, 1980.

Kutner, Janet. "Art & Artists: Exhibition Brushes Humor, Fear: Bosman Plays with Emotional Extremes," *Dallas Morning News,* March 7, 1982.

Lawson, Thomas. "Richard Bosman," *Artforum,* vol. 20, January 1982, p. 80.

Levin, Kim. "The Times Square Show," *Arts Magazine,* vol. 55, no. 1, September 1980, pp. 87-89.

Lowe, Ron. "Exhibition Tracks Artist's Growth/Bosman's Art Concerned with Content," *Fort Worth Star-Telegram,* March 7, 1982.

Parks, Addison. "Richard Bosman," *Arts Magazine,* vol. 56, no. 1, September 1981, p. 11.

Phillips, Deborah. "Richard Bosman," *Arts Magazine,* vol. 55, no. 5, January 1981, p. 13.

Print Collector's Newsletter, "Richard Bosman: Man Overboard," vol. XIII, March/April 1982, p. 4.

Ratcliff, Carter. "Narrative," *Print Collector's Newsletter,* vol. XII, no. 6, January/February 1982, pp. 170-73.

Schjeldahl, Peter. "Anxiety as a Rallying Cry," *Village Voice,* September 16-22, 1981.

Siegel, Jeanne. "Richard Bosman, Stories of Violence," *Arts Magazine,* vol. 57, April 1983, pp. 126-28.

Simon, Joan. "Double Takes," *Art in America,* vol. 68, no. 8, October 1980, pp. 113-17.

Smith, Roberta. "Art: Spacewalk," *Village Voice,* October 21 – 27, 1981.

Tatransky, Valentin. "Illustration & Allegory," *Arts Magazine,* vol. 55, no. 1, September 1980, p. 4.

ROGER BROWN

ARTIST'S STATEMENT

Until the 19th century the artist was a positive force among a number of professions which together molded society from generation to generation. Somehow the 19th century turned everything upside down until it seemed the very purpose of the artist was changed into being a negative force in order to tear down any tradition that remained from the past or anything that smelled of establishment. Unfortunately this situation did not free European art from the decadent mannerist aesthetics imposed by European Court life.

Today artists seem to be at the forefront of all doomsday predictions, especially

those which blame our own culture for all the past and future evils of the world. Undisciplined spontaneity seems to be the rule in art, contradicting centuries of great art which was produced by artists working within strict cultural styles.

It is my desire to express pride in my own culture in my art and to turn away from paying lip service to Europe's anachronistic mannerist aesthetics and the social cultural anarchy it continues to help produce.

Born in Hamilton, Alabama, 1941. Attended the Art Institute of Chicago (B.F.A. 1968; M.F.A. 1970). Lives in Chicago, Illinois.

For Biographical and Bibliographical information prior to 1980, please refer to *Roger Brown* by Mitchell Douglas Kahan, with contributions by Dennis Adrian and Russell Bowman, Montgomery Museum of Fine Arts, Montgomery, Alabama, 1980.

SELECTED SOLO EXHIBITIONS

1981 – Phyllis Kind Gallery, New York (also '82); Mayor Gallery, London, England 1983 – Asher/Faure Gallery, Los Angeles, CA

SELECTED GROUP EXHIBITIONS

1981 – *American Landscape: Recent Developments,* Whitney Museum of American Art, Fairfield County, Stamford, CT; *American Painting 1930–1980,* Haus der Kunst, Munich, West Germany (exh. cat.; text by Tom Armstrong and Bernd Growe); *Religion Into Art,* Pratt Manhattan Center, New York 1982 – *Beast: Animal*

Imagery in Recent Art, Institute for Art and Urban Resources at P.S. 1, Long Island City, NY; *Chicago on Paper,* Ray Hughes Gallery, Brisbane, Australia; *Contemporary Prints: The Figure Beside Itself,* University of Massachusetts at Amherst; *From Chicago,* Pace Gallery, New York (exh. cat.; text by Russell Bowman); *Painting and Sculpture Today,* Indianapolis Museum of Art, Indiana (exh. cat.; text by Helen Feralli and Robert A. Yassin), *Recent Directions,* Milwaukee Museum of Art, WI; *Selections from the Dennis Adrian Collection,* Museum of Contemporary Art, Chicago, IL (exh. cat.; intro. by John Hallmark Neff, text by Dennis Adrian, Mary Jane Jacob, Lynn Warren, and Naomi Vine); *The Atomic Salon,* Ronald Feldman Gallery, New York; *Poetic Objects,* Washington Project for the Arts, Washington, D.C. 1983 – *Alternative Approaches to Landscape,* Thomas Segal Gallery, Boston, MA; *Contemporary Landscape Painting,* Freedman Gallery, Albright College, Reading, PA (traveled); *Humor in Art,* Thorpe Intermedia Gallery, Sparkhill, NY; *The Last Laugh,* Southern Ohio Museum and Cultural Center, Portsmouth (traveled)

SELECTED BIBLIOGRAPHY

Articles and Reviews

Artner, Alan. "Koffler was Right: Move Scores Well for Local Artist," *Chicago Tribune,* May 3, 1982, p. 16.
——. "Art: MCA Rounds Up Dennis Adrian's Maverick Herd," *Chicago Tribune,* February 7, 1982.
Blinderman, Barry. "A Conversation with Roger Brown," *Arts Magazine,* vol. 55, no. 9, May 1981, pp. 98-99.

Elliot, David. "Collector Adrian: A Gambler Who Loves Wild Cards," *Chicago Sun-Times,* February 14, 1982, p. 7.
Hanson, Henry. "The Entry of Roger Brown Into His Own in 1981," *Chicago Magazine,* vol. 30, February 1981, pp. 142-47.
——. "Upfront/Artist Paints His Revenge on Chicago Critics," *Chicago Magazine,* vol. 31, November 1982.
Harris, Susan E. "Reviews/Roger Brown," *Arts Magazine,* vol. 57, November 1982, pp. 58-59.
Kingsley, April. "Chicago/The Look," *Art Express,* vol. 2, January – February 1982, pp. 44-45.
Larson, Kay. "Art," *New York Magazine,* October 11, 1982, p. 78.
Ratcliff, Carter. "Narrative," *Print Collector's Newsletter,* vol. XII, no. 6, January/February 1982, pp. 170-73.
Russell, John. "'The Hairy Who' and Other Messages from Chicago," *New York Times,* January 31, 1982.
——. "Art; Roger Brown, New Chicago Painter," *New York Times,* September 24, 1982, p. C20.
Shepard, Michael. "Art/Chicago Type," *The Sunday Telegraph* [London], January 4, 1981.
Smith, Roberta. "Roger Brown Lights Up," *Village Voice,* October 5, 1982, p. 99.
——. "Munich and Chicago," *Village Voice,* February 16, 1982, p. 95.
Upshaw, Reagan. "Kind Stable Sets Pace in Manhattan," *New Art Examiner,* May 1982.
——. "Reviews: Roger Brown at Phyllis Kind," *Art in America,* vol. 69, no. 6, Summer 1981, pp. 131-32.

LINDA BURGESS

ARTIST'S STATEMENT

When I moved to Alabama, it was really a return. I settled within 30 miles of my grandmother's house in a town of barely 4,000 souls. My father's reaction to my move from the metropolitan New York area to the land of his birth was one of relief. I had emerged unscathed from my sojourn in the north and was settling in safe harbor. In actuality, I had stepped out of the pan and into the fire.

My first week in west central Alabama brought hurricane Frederick.

The second week brought a tornado that touched the outskirts of Town. Devastating a pecan orchard on the west side of Highway 5, it spared the mobile home across the road.

The third week the tile man came to retile my bathroom. I left him working and arranged to return at lunch. I came home as planned to find the bathroom finished beautifully and the tile man dead in my backyard.

One night, while home alone, I noticed some movement out my rear window. Investigating, I peered outside and directly met the eyes of a man staring back at me. I ran screaming out the front door and into the night. Sheer instinct takes over at such times.

Soon after, I was travelling through a thunderstorm when lightning struck no further than twelve feet from me. I remember how that bolt locked with the ground for what seemed an eternity. The intense sensation of the dry static heat on my face is a feeling I will not soon forget.

Days later I was flying home from Atlanta. Lightning struck the plane. We had just crossed over the Alabama state line. I believe it was at this time I began to fear for my life.

My work began to change and the imagery reflected my experiences. Houses exploded, tornadoes threatened and storms loomed above otherwise placid settings. The occurrence or anticipation of violence became a prevalent theme, but presented in terms translatable to the human experience. My paintings are less about tornadoes laying waste the landscape and more about the human dilemma. They are less about the obvious and more about allusion. I see the imagery as a particular that is symbolic of a whole.

It is important to know that my recent work little resembles these earlier seminal paintings. They, however, initiated a direction and introduced concerns that are central to my current work.

Born in Coral Gables, Florida, 1954. Attended Appalachian State University, Boone, North Carolina (B.A. 1977); Rutgers University, New Brunswick, New Jersey (M.F.A. 1979). Lives in Birmingham, Alabama.

SELECTED SOLO EXHIBITIONS

1977 – Regional Gallery of Art, Boone, NC; Dogwood Gallery, Boone, NC 1979 – Mason Gross School of the Arts, Rutgers University, New Brunswick, NJ 1980 – Judson College, Marion, AL 1982 – Kennedy Art Gallery, Birmingham Southern College, AL; Southeast Center for Contemporary Art, Winston-Salem, NC 1983 – Hodges-Taylor Gallery, Charlotte, NC

SELECTED GROUP EXHIBITIONS

1974 – Miami-Dade Community College, FL 1975 – Dogwood Gallery, Boone, NC; *NOWNS,* University Gallery, Appalachian State University, NC 1976 – *Women Artists,* Dogwood Gallery, Boone, NC 1977 – *New Orleans Museum of Art Biennial,* New Orleans Museum of Art, LA (exh. cat.; text by Jack Boulton) 1978 – Rutgers University Art Gallery, New Brunswick, NJ (also '79); Mason Gross School of the Arts, Rutgers University, New Brunswick, NJ 1979 – The Real Gallery, Boone, NC (also '80); Douglass Gallery, Rutgers University, New Brunswick, NJ 1980 – *Alabama Women Artists,* University of Montevallo, AL; *Grandfather Mountain Invitational,* Grandfather Mountain, NC (also '81); D. Hodges Gallery, Charlotte, NC; *Lawndale Invitational,* Lawndale Annex of the University of Houston, TX; *Up Front Invitational,* Up Front Gallery, Memphis, TN 1981 – *Birmingham Arts Alliance Invitational,* Birmingham, AL; *Drawing International,* University of Montevallo, AL; *Schreveport Art Guild National,* Meadows Museum of Art, LA; Quadrum Gallery, Boston, MA 1982 – Memphis State University, Memphis, TN 1983 – *New Orleans Triennial,* New Orleans Museum of Art, LA (exh. cat.; text by Linda L. Cathcart, William Fagaly); *Network Southeast,* Nexus Gallery, Atlanta, GA; *16 Artists,* Birmingham Museum of Art, Birmingham, AL; *Drawing Southeast,* Atlanta Arts Festival, Atlanta, GA (exh. cat.; text by John D. Lawrence)

SELECTED BIBLIOGRAPHY

Articles and Reviews

Kalil, Susie. "1983 New Orleans Triennial: An Interview with Guest Curator Linda Cathcart," New Orleans Museum of Art, *Arts Quarterly,* vol. 5, issue II, 1983.

BRUCE CHARLESWORTH

ARTIST'S STATEMENT

The characters I play in my work are, in most cases, "normal" people to whom things happen. In the videotape portion of *Projectile,* the persecuted crime suspect, Johnson, is a reactive type to the extreme. He does little more than avoid policemen, and his narration of the story is entirely by way of title cards. A similar character appears in my 1983 series of cibachrome photographs. His connection to events is often peripheral, or he is unaware of the directness and severity of his involvement.

Other characters I write for myself retain a reactive stance while having very specific personalities. Delusions and obsessions drive these people to radical circumstances, or they arrive there because outside events make alternatives impossible. When violence happens, it comes from chaotic external sources. Reasons are seldom given, resulting in works without neat solutions.

Projectile, as installed at Walker Art Center in early 1982, was a five-room piece with video and audiotapes. Several of the rooms represented a bachelor pad/bomb shelter containing bar, recreation equipment, and gun-turret window. In one room, an unknown force had blasted through the rafters, trailing debris across the floor into an adjoining locker room shower stall. In both installation and videotape, the projectile was not clearly the result of either storm or bomb.

Projectile's display of facts without analysis defies the movie-detective genre it loosely resembles. Although more straightforward than other works I've done, its allegorical structure and blatant artifice distance *Projectile* from reality.

Born in Davenport, Iowa, 1950. Attended University of Northern Iowa, Cedar Falls (B.A. 1972); University of Iowa, Iowa City (M.A. 1974, M.F.A. 1975). Lives in Minneapolis, Minnesota.

SELECTED SOLO EXHIBITIONS

1975 – *Doris Day in Flames,* Clapp Hall, University of Iowa, Iowa City 1978 – *Tourist,* South Hennepin Avenue at 31st Street, Minneapolis, MN [outdoor slide installation] 1979 – Glenn Hanson Gallery, Minneapolis, MN 1980 – *Eddie Glove,* Walker Art Center, Minneapolis, MN 1981 – *Special Communiques,* Film in the Cities, St. Paul, MN [included video] 1982 – *Lost Dance Steps,* Artists Space, New York; *Three Tapes: Recent Video Works,* Film in the Cities, St. Paul, MN 1983 – *New Photographs: Project Studios One,* Institute for Art and Urban Resources at P.S. 1, Long Island City, NY

SELECTED GROUP EXHIBITIONS

1976 – *Iowa Artists,* Des Moines Art Center, IA; *Three Filmmakers,* Twin Cities Metropolitan Art Alliance, Minneapolis, MN [film]; University of Iowa Museum of Art, Iowa City [film] 1977 – *Moving Image Makers,* Minneapolis Institute of Arts, MN [film] 1979 – *American Vision,* Washington Square East Galleries, New York; *Inch Art Invitational,* Rochester Art Center, MN; *Made in Minnesota,* Rochester Art Center, MN; *Recent Acquisitions,* Minneapolis Institute of Arts, MN; *SX-70,* Center for Exploratory and Perceptual Arts (CEPA), Buffalo, NY (exh. cat.; ed. by Ralph Gibson; traveled) 1980 – *Instantanés,* Musée National d'Art Moderne, Centre Georges Pompidou, Paris, France (exh. cat.; traveled); *Likely Stories,* Castelli Graphics, New York; *Midwest Photo,* The Midwest Museum of Art, Elkhart, IN (exh. cat.); *Painting/Drawing,* Kiehl Gallery, St. Cloud State University, MN 1981 – *Five Emerging Artists,* Minneapolis College of Art and Design, MN; *Persona,* The New Museum, New York (exh. cat.; text by Lynn Gumpert, Ned Rifkin); *Selections from the Permanent Collection: 1969–80,* Minneapolis Institute of Arts, Minneapolis, MN 1982 – *Eight Artists: The Anxious Edge,* Walker Art Center, Minneapolis, MN (exh. cat.; essay by Lisa Lyons) 1983 – *Biennial Exhibition,* Whitney Museum of American Art, New York (exh. cat.); *Language, Drama, Source and Vision,* The New Museum of Contemporary Art, New York

SELECTED BIBLIOGRAPHY

Articles and Reviews

Ellis, Valerie. "You Never Can Tell... Bruce Charlesworth," *Changing Channels* [Minnesota], Winter 1982, p. 9.

Ferrer, Esther. "Polaroid Art, et Arte de lo Instantáneo," *ERE,* July 23, 1980, p. 53.

Glendenning, Margherita. "Artist's Self-Portrait Photos Get Beneath the Facade," *St. Paul Dispatch,* August 23, 1979, p. 22.

Glueck, Grace. "Video Comes Into Its Own at the Whitney Biennial," *New York Times,* April 24, 1983, pp. H33, 36.

Grundberg, Andy. "Fairy Tales," *Soho News,* July 23, 1980, p. 34.

Heartney, Eleanor. "Artists on the Edge at Walker: Where is the Faith?," *Twin Cities Reader,* vol. 7, no. 18, May 6–12, 1982, pp. 11, 15.

Hegeman, William. "Looking at Art," *Minneapolis Tribune,* September 2, 1979, p. G10.

——. "Charlesworth Photos Odd but Compelling," *Minneapolis Tribune,* July 27, 1980, p. G3.

King, Shannon. "Artist Develops Tale with Photos," *Minneapolis Star,* August 1, 1980, p. C6.

Kraskin, Sandra. "Five Emerging Artists," *Art Express,* vol. 2, no. 1, January/February 1982, p. 63.

Lifson, Ben. "Summer Stock," *Village Voice,* vol. 25, no. 29, July 16–22, 1980, p. 72.

McDarrah, Fred. "Likely Stories," *Village Voice,* vol. 25, no. 30, July 23–29, 1980, p. 53.

Matheny, Dave. "Walker's Show on Anxiety is an Exercise, Not an Examination," *Minneapolis Star and Tribune,* April 23, 1982, pp. B1, 5.

Preddie, Sandra. "Artworks Take Viewer to the Edge," *St. Paul Pioneer Press,* April 23, 1982, pp. C3-4.

Schjeldahl, Peter. "Curator, Cure Thyself," *Village Voice,* vol. 27, May 18, 1982, p. 87.

Skarjune, David. "Remote Control Vision," *Minnesota Daily,* February 19, 1981, p. AE12.

Sterritt, David. "Cinema vs. Video: A Friendly Feud," *Christian Science Monitor,* July 19, 1983, p. 18.

Thornton, Gene. "Photography View: Narrative Works," *New York Times,* August 31, 1980, Section 2, p. 19.

Artist's Writings

"The Man in the Back Seat," *Working Papers IV,* March 1983, pp. 1-12.

MICHAEL COOK

ARTIST'S STATEMENT

RADIATION REMAINS THE SAME/ FUTURE GENERATIONS WILL BE PERFECT/THANKS TO GENETIC MUTATIONS/IN ONE GENERATION/PRAISE BE TO RADIATION/WHICH REMAINS THE SAME/IN YOU AND ME/SO..../I CAN SEE THAT RADIATION REMAINS THE SAME/IN YOU AND ME/A NEW PERFECT HIGHER FORM OF LIFE/FREE FROM STRIFE/THANKS TO GENETIC MUTATIONS/IN JUST ONE GENERATION/PRAISE BE TO RADIATION/WHICH REMAINS THE SAME/IN YOU AND ME/A-BOMB BLASTS/SEEM TO LAST/LONGER, BECAUSE/THERE IS NO FUTURE/NO PAST/WHEN RADIATION REMAINS THE SAME/IN YOU AND ME/I CAN SEE THAT/ RADIATION REMAINS THE SAME/ IN YOU AND ME/WHAT DO THEY KNOW/ABOUT WHERE ELECTRONS GO/WHEN THEY REACH CRITICAL MASS/THEY REACT AWFULLY FAST/SAY A CATHOLIC MASS/BECAUSE/RADIATION REMAINS THE SAME/IN YOU AND ME/I CAN SEE THAT/RADIATION REMAINS THE SAME/IN YOU AND ME/DO NOT FEAR/THE THINGS THAT YOU HEAR/FROM ECOLOGICAL/"HAVE A NICE DAY" PIE FACES/IT'S ALL FOR THE BEST/SO TAKE A REST/ BECAUSE/RADIATION REMAINS THE SAME/IN YOU AND ME/I CAN SEE THAT/RADIATION REMAINS THE SAME/IN YOU AND ME/A REACTOR IN EVERY HOME/WILL GIVE YOU ENOUGH/RAW MATERIAL ALONE/FOR A BOMB CLONE/DON'T WORRY ABOUT LEAD SHIELDS/BECAUSE YOUR BODY CONTAINS/ENOUGH PLUTONIUM TO YIELD/A 50 MEGATON EXPLOSION/SO.... I CAN SEE THAT/RADIATION REMAINS THE SAME/IN YOU AND ME

Born in Ramey, Puerto Rico, 1953. Attended Florida State University, Tallahassee (B.F.A. 1975); University of Dallas, Texas (M.A. 1976); University of Oklahoma (M.F.A. 1978). Lives in Kensington, California.

SELECTED SOLO EXHIBITIONS

1976 – *All the Stuff / A You See Everyday, Everyweek, Everyyear, Everylife and Take for Granted but Never Thought Art,* University of Dallas, TX 1978 – *Remains,* Clifford Gallery, Dellas, TX; *Container, Contained, Remains,* Lightwell Gallery, University of Oklahoma, OK 1979 – *Screen Test: Work in Progress,* Tangeman Fine Arts Gallery, Cincinnati, OH 1981 – *Selected Video Works,* Contemporary Arts Center, Cincinnati, OH 1982 – *Michael Cook: Drawings,* Riecher Gallery, Barat College, Chicago, IL; *Michael Cook / Peter Huttinger: Paintings, Drawings, Constructions,* N.A.M.E. Gallery, Chicago, IL 1983 – *Michael Cook: Paintings and Drawings,* The Grayson Gallery, Chicago, IL

SELECTED GROUP EXHIBITIONS

1974 – *Temple Show,* University Gallery, Florida State University, Tallahassee 1975 – *Drawings,* Haggerty Art Gallery, University of Dallas, TX 1976 – *T.C.A.S. 3,* Mountainview College, Dallas, TX 1977 – *Button-Button,* Fosdick Nelson Gallery, New York State College of Ceramics, Alfred, NY; *Annual Experimental Video Exhibition,* Lightwell Gallery, University of Oklahoma, OK [video]; *Experimental Film and Video Showing and Seminar,* Idaho State

University, ID [video]; *Magnetic Image 3,* Third Atlanta National Invitational Video Screening, High Museum of Art, Atlanta, GA [video]; *In the Crease of the Map,* Fred Jones Museum of Art, Norman, OK; *Tension Situations,* University Gallery, Florida State University, Tallahassee; *BEO: Pre-Publication Exhibition,* Gallery 413, Atlanta College of Art, GA 1978 – *Video Art,* Norman Cable T.V., May 5, 1978, Channel 14 [video]; *Magnetic Image 4,* Fourth Atlanta National Invitational Video Screening, Atlanta College Gallery, GA (exh. cat.; text by Ben Davis); *Senoj/BEO Exhibition,* Atlanta College Gallery, GA; *The 77th Annual Exhibition by Artists of Chicago and Vicinity: Works on Paper,* Art Institute of Chicago, IL (exh. cat.; text by Ester Spark) 1979 – *Video Tapes and Drawings,*

Hunter Gallery, New York; *Magnetic Image 5,* Fifth Atlanta National Invitation Video Screening, Atlanta College Gallery, GA 1980 – *New Dimension-Time,* Museum of Contemporary Art, Chicago, IL (exh. brochure; text by Pauline A. Saliga); *Athens Video Festival,* OH [work broadcast on Channel 12, Athens Cable T.V.] [video]; *Radiation Remains the Same,* Image Union, WTTW Channel 11, July 10, 11, Chicago, IL [video]; *Selected Video Works,* Cable Atlanta, Channel 10, February 23, 1981, 9:00 p.m. [video]; *Invitational Drawing Exhibition,* C.A.G.E., Cincinnati, OH; *Working Drawings,* Hunter Gallery, New York (traveled) 1982 – *War Games,* The Kitchen, New York 1983 – *Systems and Structures: Seven Chicago Artists,* University of Wisconsin Art Gallery, Green Bay (traveled)

SELECTED BIBLIOGRAPHY

Articles and Reviews

Daniels, Sarah. "BEO," *Contemporary Art Southeast,* vol. 1, no. 3, 1977.
Elliott, David. "Chicago is Enjoying its own Eclecticism," *Art News,* vol. 81, no. 5, May 1982, p. 94.
——. "These Artists Paint Modern Visions," *Chicago Sun Times,* March 14, 1982, p. 38.
——. "New Dimensions – Time," *Chicago Sun Times,* April 6, 1980.
Kutner, Janet. "Remains," *Art News,* vol. 78, no. 3, March 1979, pp. 132–34.
Thomsan, Pat. "Review: N.A.M.E. Exhibition," *New Art Examiner,* vol. 9, no. 8, May 1982, p. 15.

Artist's Writings

BEO. Atlanta: Senoj Inc., 1979.

ROBERT FICHTER

ARTIST'S STATEMENT

How to make art to survive the end of the world? Cast your images in the very best ceramic space travel material. After all – you're headed into the void!

For a number of years now I have laughingly told various special interest groups – young artists and other interested cigarette smokers – that I was teaching my roaches and ants the REAL HISTORY OF IMAGE MAKING. Roaches and ants are real survivors. They can take a lot of hard radiation. And I thought – well they could bear the history forward into time. But now I'm not so sure. Maybe biology won't get out of this one. Ask Riddly Walker – he knows how close it can come. Well. I have to get back to my image casting.

Born in Fort Myers, Florida, 1939. Attended the University of Florida, Gainesville (B.F.A. 1963); Indiana University, Bloomington (M.F.A. 1966). Lives in Tallahasee, Florida.

SELECTED SOLO EXHIBITIONS

1970 – *Recent Photo-Drawings,* University of California, Davis 1972 – Infinite Gallery, Seattle, WA; Center of the Eye, Aspen, CO; Visual Studies Workshop (traveled) 1974 – *The Black Winged Heart,* Light Gallery, New York; Art Institute of Chicago, IL 1975 – University of New Mexico Art Gallery, Albuquerque 1976 – *Daguerrian Error,* Light Gallery, New York 1978 – San Francisco Cameraworks, CA 1980 – Robert Freidus Gallery, New York; Gulf Coast Gallery, Tampa, FL; Northlight Gallery, Arizona State University, Tempe 1981 – Los Angeles Center for Photo-

graphic Arts, CA 1982 – *Apocalyptic Visions,* Robert Freidus Gallery, New York; George Eastman House, International Museum of Photography, Rochester, NY (traveled) 1983 – Center for Creative Photography, Tucson, AZ; Mattingly Baker Gallery, Dallas, TX; Kathleen Ewing Gallery, Washington, D.C.; Fay Gold Gallery, Atlanta, GA; Klein Gallery, Chicago, IL; Koplin Gallery, Los Angeles, CA

SELECTED GROUP EXHIBITIONS

1970 – *Into the 70's,* Akron Art Institute, OH (exh. cat.; texts by Tom Muir Wilson, Orrel E. Thompson, Robert M. Doty); *The Photograph as Object 1843 – 1969,* National Gallery of Canada, Ottawa (traveled); *California Photography 1970,* University of California at Davis (exh. cat.; text by Fred R. Parker) 1971 – *Opening Exhibition,* Ohio Silver Gallery, Los Angeles,

CA; *13 Photographers,* Light Gallery, New York 1972 – *60's Continuum,* George Eastman House, International Museum of Photography, Rochester, NY 1973 – *Light and Lens,* Hudson River Museum, Yonkers, NY (exh. cat.; text by Donald L. Werner, Dennis Longwell); *Recent Acquisitions,* George Eastman House, International Museum of Photography, Rochester, NY; *Photography Into Art,* Scottish Arts Council Gallery, Edinburgh (exh. cat.; text by Pat Gilmour) 1974 – *Contemporary Photography from the Collection,* Boston Museum of Fine Arts, MA; *Photography Unlimited,* Fogg Museum, Harvard University, Cambridge, MA 1975 – Friends of Photography, Carmel, CA 1976 – *New American Graphics,* Madison Art Center, WI; *New Blues,* Arizona State University, Tempe; *Exposing Photographic Definitions,* Los Angeles, CA; Institute of Contemporary Art, Los Angeles, CA 1977 – *Painting in the Age of Photography,* Kunsthaus, Zurich, Switzerland 1978 – *The Art of Offset Printing,* Art Institute of Chicago, IL 1979 – *20 x 24" Polaroid,* Light Gallery, New York; *My Teacher, My Self,* Susan Spiritus Gallery, Newport Beach, CA 1980 – *Invented Images,* University of California, Santa Barbara (traveled); *Vis a Vis / Art & Photography,* Institute of Contemporary Art,

Boston, MA; *Aspects of the '70s; Photography: Recent Directions,* De Cordova & Dana Museum, Lincoln, MA; *Graphics Invitational,* Mint Museum, Charlotte, NC; *Birds,* Museum of Modern Art, New York 1981 – Whitney Biennial, Whitney Museum of American Art, New York; *Recent Acquisitions,* George Eastman House, International Museum of Photography, Rochester, NY 1982 – *American Photo-*Denver; J.M. Kohler Museum, Sheboygan, WI; Colorado Photographic Arts Center, Denver; Thorpe Intermedia Gallery, Sparkill, NY; *Still Lifes,* Museum of Modern Art Lending Service, New York

SELECTED BIBLIOGRAPHY

Articles and Reviews

Bellavance, Leslie. "Photographers Invite Photographers," *New Art Examiner,* May 1983.
Berendt, John. "Fichter's Spoils," *American Photographer,* vol. 9, no. 6, December 1982, pp. 70-77.
Fox, Kevin. "Galleries: Social Statements," *Dallas Downtown News,* February 28, 1983.
Glueck, Grace. "The Scene from SoHo to Tribeca: Robert Fichter," *New York Times,* January 30, 1981, Sec. C.

Grundberg, Andy. "Photography on the Edges: Robert Fichter," *Soho Weekly News,* vol. 7, no. 35, May 28, 1980.
Hinson, Mark. "Artist's Work Has Bite, Wit," *Florida Flambeau* [Tallahassee], September 2, 1982, pp. 9, 15.
Johnson, Brooks. "Contemporary Color: Two Views (II)," *Proofs: Photography Alliance of the Chrysler Museum,* vol. 1, no. 2, March / April 1981, pp. 1-2.
Jussim, Estelle. "The Manifold Shapes of Time," *Polaroid Close-Up,* vol. 14, no. 1, April 1983.
Welch, Marguerite. "Contemporary Color: Two Views (I)," *Proofs: Photography Alliance of the Chrysler Museum,* vol. 1, no. 2, March / April 1981, pp. 1-3.
Zelevansky, Lynn. "Robert Fichter," *Flash Art,* no. 3, March 1983.

Books

Contemporary Photographers. New York: St. Martin's Press, 1981.
North, Ian, ed. *International Photography: 1920 – 1980.* Sydney: Australian National Gallery, 1982.
Sobieszek, Robert, ed. *Robert Fichter: Photography and Other Questions.* Albuquerque: University of New Mexico Press, 1983.

REVEREND HOWARD FINSTER

ARTIST'S STATEMENT

…I am drowned in visions but my hand clears the top, I found no signs of a space to stop….

Born in Valley Head, Alabama, 1916. Lives in Sumerville, Georgia.

SELECTED SOLO EXHIBITIONS

1977 – Phyllis Kind Gallery, New York (also '80) 1978 – Janet Fleisher Gallery, Philadelphia, PA 1979 – Wake Forest University, Winston-Salem, NC 1980 – *Man of Vision: Man of the Heart,* Botanical Gardens, University of Georgia, Athens 1981 – Braunstein Gallery, San Francisco, CA 1982 – *Currents: Reverend Howard Finster,* The New Museum, New York (exh.

brochure; text by Jesse Murry); Phyllis Kind Gallery, Chicago, IL

SELECTED GROUP EXHIBITIONS

1976 – *Missing Pieces: Georgia Folk Art,* Atlanta Historical Society, GA (exh. cat.; traveled) 1978 – *First in the Hearts of his Countrymen: Folk Art Images of George Washington,* Fraunces Tavern Museum,

New York; *The Heart in American Folk Art,* Museum of American Folk Art, New York; *Naive Visions,* Virginia Commonwealth University, Richmond 1979 – *America Now* (organized by United States International Communications Agency, Washington, D.C.; traveled); *Contemporary American Folk Art,* University of Richmond, VA; *Outsiders,* Memorial Art Gallery, University of Rochester, NY 1980 – *Folk Art U.S.A. Since 1900 from the Collection of Herbert Waide Hemphill, Jr.,* Abby Aldrich Rockefeller Folk Art Center, Williamsburg, VA (exh. cat.; intro. by Beatrix T. Rumford); *Masterpieces of Folk Art,* Phyllis Kind Gallery, Chicago, IL; *Masterpieces of Folk Art,* Otis/Parsons Gallery, Otis Art Institute of Parsons School of Design, Los Angeles, CA 1981 – *Icon/ Logos,* The Alternative Museum, New York; *Religion Into Art,* Pratt Manhattan Center, New York; *Transmitters: The Isolated Artist in America,* Philadelphia College of Art, PA (exh. cat.; essay by Richard Flood, text by Michael and Julie Hall); *This Side of Paradise,* Concord Gallery, New York; *American Folk Art Since 1900 from the Collection of Herbert Waide Hemphill, Jr.,* Milwaukee Art Museum, WI (exh. cat.; essays by Michael Hall, H.W. Hemphill, Russell Bowman, Donald Kuspit; traveled) 1982 – *A Sampling of American Folk Art,* Webb & Parsons Gallery, New Canaan, CT; *More Than Land or Sky: Art from Appalachia,* National Museum of American Art, Washington, D.C. (exh. cat.); *What I Do for Art,* Just Above Midtown/Downtown, New York 1983 – *Apocalyptic and Utopian Images in Contemporary Art,* Payne Gallery, Moravian College, Bethlehem, PA (exh. cat.)

SELECTED BIBLIOGRAPHY

Articles and Reviews

Bethany, Marilyn. "Folk Sculpture, A Quirkily American Art on View," *New York Times,* January 14, 1983, p. C22.

Brewster, Todd. "Fanciful Art on Plain Folk," *Life Magazine,* vol. 3, June 1980, pp. 112-13.

Carlson, Brigitta. "A Preacher's Vision of Gardening," *Winston-Salem Journal,* March 9, 1980, p. C7.

Larson, Kay. "Now Voyeur," *Village Voice,* June 9, 1980, p. 72.

Murry, Jesse. "Reverend Howard Finster: Man of Visions," *Arts Magazine,* vol. 55, no. 2, October 1980, pp. 161-64.

Phillips, Deborah C., *Arts Magazine,* vol. 55, no. 1, September 1980, p. 24.

Schjeldahl, Peter. "About Reverence," *Village Voice,* August 31, 1982, p. 73.

DANA GARRETT

Born in Los Angeles, California, 1953. Lives in New York City.

SELECTED SOLO EXHIBITIONS

1980 – Robert Miller Gallery, New York (also '82) 1982 – San Jose Institute of Contemporary Art, CA 1983 – Tracey Garet/Michael Kohn Gallery, New York (exh. cat.; text by Michael Kohn)

SELECTED GROUP EXHIBITIONS

1981 – *New York/New Wave,* Institute for Art and Urban Resources at P.S. 1, Long Island City, NY 1982 – Landscapes, Robert Miller Gallery, New York; *La Photographie en Amérique,* Galerie Texbraun, Paris, France; *New York Panorama,* Stockholm International Expo, Sweden; Nature Morte Gallery, New York 1983 – *Young New York Artists/1983,* Belleville Arts Commission, IL

SELECTED BIBLIOGRAPHY

Articles and Reviews

Henry, Gerrit. "New York Review: Dana Garrett," *Art News,* vol. 79, December 1980, p. 200.

Kohn, Michael. "Dana Garrett: l'Art Noir," *Arts Magazine,* vol. 56, April 1982, pp. 120-21.

Parks, Addison. "Reviews," *Arts Magazine,* vol. 55, no. 3, November 1980, p. 27.

FRANK GOHLKE

ARTIST'S STATEMENT

When a tornado laid waste a ten-mile-long swath through my home town, Wichita Falls, Texas, it in effect undid the work of a generation of the city's inhabitants. Our myths of progress tell us that time's flow is always forward, toward higher and higher levels of order. But the tornado, which is a highly ordered release of an enormous amount of energy in a very short time, enters the human realm and the result is apparent regress, into formlessness and chaos. The chaos is only apparent, however, for in the patterning and distribution of the wreckage is displayed the form of the event itself. The first set of photographs describes with the look of dispassion, the particular constellations of facts in which the shape of the stupendous forces can be seen clearly.

But it was emphatically something more than scientific curiosity which impelled me to make the pictures, and to remake them as accurately as possible. The fact that it was my home town was crucial, because in cutting through those neighborhoods I had known all my life, it also cut through the fabric of my memory. It was as if my personal history had been ruptured, not only the history of the community; and it aroused as well those fears we all share in these times of an end of history altogether.

The time I had to photograph was short, two days, and I was back into my everyday life before I had even begun to absorb what I had seen. The more I lived with the photographs, the more incomplete they felt. They described, in cultural terms, a discontinuity, and erasure. But to understand this collision between the natural and human orders, one had to consider the continuities as well. The tornado was powerful beyond comprehension, but it was also ephemeral; to suggest both qualities, the photographs had to have a temporal extension of their own. They had to create a history for themselves that was in opposition to the radical disruption of communal and personal history that the tornado caused in Wichita Falls. It was not my idea to remake the photographs; it was a necessity that grew out of the photographs themselves.

Born in Wichita Falls, Texas, 1942. Attended the University of Texas, Austin (B.A. 1964); Yale University, New Haven, Connecticut (M.A. 1967).Lives in Minneapolis, Minnesota.

SELECTED SOLO EXHIBITIONS

1969 – Middlebury College, VT 1971 – The Underground Gallery, New York 1974 – George Eastman House, International Museum of Photography, Rochester, NY 1975 – Light Gallery, New York (also '78, '81, '82) 1975 – Amon Carter Museum of Western Art, Fort Worth, TX 1977 – Boston Museum School, MA 1978 – Sheldon Memorial Art Museum, University of Nebraska, Lincoln; Museum of Modern Art, New York 1980 – University Gallery, University of Massachusetts, Amherst; Carleton College, Northfield, MN 1981 – Friends of Photography, Carmel, CA; University of Rochester, NY; University of Tulsa, OK 1983 – Daniel Wolf, Inc., New York

SELECTED GROUP EXHIBITIONS

1970 – *Contemporary Photographers VI,* George Eastman House, International Museum of Photography, Rochester, NY 1972 – *'60s Continuum,* George Eastman House, International Museum of Photography, Rochester, NY 1973 – *Photographers: Midwest Invitational,* Walker Art Center, Minneapolis, MN (exh. cat.) 1974 – *Frank Gohlke and Edward Ranney,* Art Institute of Chicago, IL; *Light and Substance,* University of New Mexico, Albuquerque 1975 – *Twelve Photographers: Minnesota Invitational,* Minneapolis Institute of Arts, MN 1976 – *Photography for Collectors,* Museum of Modern Art, New York; *Recent American Still Photography,* Fruitmarket Gallery of the Scottish Arts Council, Edinburgh; *Six American Photographers,* Thomas Gibson Fine Arts, London, England 1977 – *Courthouse,* Museum of Modern Art, New York traveled) 1978 – *Minnesota Survey: Six Photographers,* Minneapolis Institute of Arts, MN (exh. cat.); *Mirrors and Windows,* Museum of Modern Art, New York (exh. cat.; text by John Szarkowski) 1979 – *Photographers of the 1970s,* Art Institute of Chicago, IL; *Attitudes: Photography in the 1970s,* Santa Barbara Museum, CA 1980 – *New Landscapes Part II,* Friends of Photography, Carmel, CA 1981 – *Frank Gohlke and Nick Nixon,* Kalamazoo Institute of Arts, MI; *American Landscapes,* Museum of Modern Art, New York; *Photography: A Sense of Order,* Institute of Contemporary Art, University of Pennsylvania, Philadelphia 1982 – *New American Photography,* University Memorial Center Gallery, University of Colorado, Denver 1983 – *New Work by Eight Photographers,* Daniel Wolf, Inc., New York

SELECTED BIBLIOGRAPHY

Articles and Reviews

"A Photographer's View of Grain Elevators," *GTA Digest,* March/April 1979, pp. 20-23.

Coleman, A.D. "Latent Image," *Village Voice,* October 28, 1971, pp. 35-36.

Grundberg, Andy. "Photography View: A Respect for Tradition," *New York Times,* section 2, February 27, 1983, p. 29.

——. "Reflecting the Supremacy of Nature," *New York Times,* Sunday, March 28, 1982, pp. 35-38.

Hegeman, William. "Artist with camera discovers hospitable climate in Minnesota," *Minneapolis Tribune,* Sunday, October 1, 1978, pp. 1D, 8D.

Klein, Sami. "Showing an America of Wheat and Wheaties," *Minneapolis Star,* June 16, 1979, pp. 12-13.

Lifson, Ben. "Frank Gohlke's Entrance into the Provinces," *Village Voice,* May 8, 1978, p. 80.

Picard, Peter. "Midwestern Icons," *Minnesota Daily,* October 26, 1979, p. 10AE.

Pretzer, Michael. "Frank Gohlke, Chester Michalik," *New England Journal of Photography,* #4, Summer 1980, p. 26.

Ratcliff, Carter. "Route 66 Revisited: The New Landscape Photography," *Art in America,* vol. 64, no. 1, January/February 1976, pp. 86-91.

West, Stephen. "Report from the Provinces," *Village Voice,* February 10, 1975, pp. 83-84.

Books

Danese, Renato, ed. *American Images, New Work by 20 Contemporary Photographers.* New York: 1979, pp. 110-19.

LOUIE GRENIER

ARTIST'S STATEMENT

It's a wrap.

Born in Chicago, Illinois, 1945. Attended Southern Illinois University, Carbondale (B.A. 1972). Lives in New York City.

SELECTED SOLO EXHIBITIONS

1976 – *Transient Touch; Divorce Photographer Goes Straight,* Victory Gardens Theatre, Chicago, IL [performance, film] 1979 – Albany Public Library, NY; St. John's University, Jamaica, NY 1980 – Anthology Film Archives, New York; Rutgers University, New Brunswick, NJ 1982 – Danceteria, New York; Hallwalls, Buffalo, NY [performance, video]; WTTW-TV, Chicago, IL [broadcast] 1983 – *Videoville,* WNYC-TV, New York [broadcast]

SELECTED GROUP EXHIBITIONS

1977 – *15th New York Film Festival,* Alice Tully Hall, New York (exh. cat.; essay by Wendy Keys) [film] 1978 – *Video Screenings,* Global Village, New York 1979 – *Anthology Video,* Holly Solomon Gallery, New York; *Artist's Television Network,* Manhattan Cable TV, New York; *Bizarreness, Humor, Fantasy,* Inter-Media Art Center, Bayville, NY; *CAPS Fellowship Recipients,* Institute for Art and Urban Resources at P.S. 1, Long Island City, NY (traveled); Everson Museum of Art, Syracuse, NY; Experimental TV Center, Binghamton, NY; *4th Annual Video Celebration,* Marymount College, Tarrytown, NY; Media Study, Inc., Buffalo, NY; *Over the Rainbow,* The Kitchen, New York; Port Washington Public Library, NY; Snug Harbor Cultural Center, Staten Island, NY; Visual Studies Workshop, Rochester, NY 1980 – *Electronic Art Concepts & Images,* Chicago Editing Center, IL (traveled); *15th Annual Avant-Garde Festival of New York,* 55th Street Terminal & Hudson River, New York; *Mud Video I, III, & IV,* Mudd Club, New York; *Three Tape Comedians,* The Kitchen, New York; University of Texas, Dallas 1981 – *Funny Video Tapes,* Institute for Art and Urban Resources at P.S. 1, Long Island City, NY [paintings, video]; *Not Just for Laughs,* The New Museum, New York (exh. cat.; text by Marcia Tucker) 1982 – *Avant-Garde Follies,* The New Ballroom, New York [performance]; *Brooklyn Arts & Cultural Association,* NY; *Comedy in the Mudd,* Mudd Club, New York [performance]; *Mixed Bag; Video Art,* CBS Cable TV, New York; *NYC Art Video 2,* Global Village, New York; *Humor/Comedy,* Media Study, Buffalo, NY (exh. cat.; traveled) 1983 – *Video Around Town,* Just Above Midtown/Downtown Gallery, New York (traveled); *Video Redbar,* The Redbar, New York; *Videoville,* Pyramid Club, New York

SELECTED BIBLIOGRAPHY

Articles and Reviews

"After Hours," *Playboy,* June 1976, pp. 21-22.

Boyle, Deirdre. "Growing Up Wired," *American Film,* vol. VII, July/August 1982, pp. 21-23.

Christiansen, Richard. "Critic's Notebook; Transient Touch," *Chicago Daily News,* November 3, 1976, p. 55.

Daly, Maggie. "Transient Touch is not a massage parlor," *Chicago Tribune,* October 28, 1976, sec. 3, p. 8.

Fischer, Terry. "Openers. Divorce Courting," *Oui* [New York], vol. 6, no. 2, February 1977, pp. 15-58.

Ginsberg, Merle. "NY Video: State of the Art," *Soho Weekly News,* March 18, 1981, pp. 42-46.

Gold, Aaron. "Tower Ticker," *Chicago Tribune,* October 15, 1976, Section 2, p. 2.

Greene, Bob. "Gruesome twosomes; Marriage off track? Try photo finish," *Chicago Sun-Times,* February 25, 1976, p. 5.

Hoberman, J. "Einstein off the Beach; Three Tape Comedians," *Village Voice,* vol. 25, no. 42, October 22, 1980, p. 52.

Hytken, Sandra. "Transient Touch; Louie Grenier at the Victory Gardens Theatre," *Reader* [Chicago], vol. 6, no. 4, October 22, 1976, Sec. 1, p. 32.

Kupcinet, Irv. "Kup's column," *Chicago Sun-Times,* October 26, 1976, p. 56.

Rosenthal, Marshall. "Hot Type; Scenes from a Divorce," *Reader* [Chicago], vol. 5, no. 21, February 27, 1976, p. 4.

Tsuchiya, Arthur. "CAPS Video: Grenier, Wiener, Kriegman, Marton," *Afterimage,* vol. 7, nos. 1-2, Summer 1979, pp. 6-7.

White, Robin. "Great Expectations: Artists' TV Guide," *Artforum,* vol. 20, no. 10, Summer 1982, pp. 40-47.

Books

Page, Tim. *Hip Pocket Guide to New York.* New York: Harper & Row, 1982.

Artist's Writings

"Rude Apprenticeship Workshop," *Village Voice,* vol. 23, no. 15, April 10, 1978, p. 87.

DONALD LIPSKI

ARTIST'S STATEMENT

SOME FACTS AND NEAR FACTS WITH NO CONCLUSIONS

– To build new weapons systems requires a simple majority of Congress; to sign a treaty limiting or reducing weapons requires a ⅔ majority of the Senate.

– There are over 10 million AK-47 Soviet assault rifles in circulation around the world.

– Lebanon has about 40 separate armed militias.

– Since 1970, USSR arms sales to the Third World have increased 251%, U.S. arms sales to the Third World have increased 450%.

– Weapons sales bring in one quarter of all the hard currency earned by the USSR.

– 1980 world weapons transfers totaled 120 billion dollars, just about equal to world transfers of food.

– The U.S. left behind 800,000 M-16 assault rifles in Vietnam.

– Private sales of U.S. arms of less than 25 million dollars need no approval of Congress.

– The GAU-8 30mm Gatling gun carried by the A-10 – a close support aircraft, fires milk-bottle-sized shells with expended uranium cores (for mass) at the rate of 4200 rounds a minute.

– The Hughes AIM 54A Phoenix air-to-air missiles, with a range of close to 100 miles, cost more than $1,000,000 each.

– The AWACS aircraft can track 600 targets at once at a range of 250 miles.

– The SR-71 "Bluebird" reconnaissance plane can map over 100,000 miles of the Earth's surface in less than an hour.

– Parts for the F-18 fighter jet come from 20,000 companies in 44 states

– Minute Man missiles have only been test fired from operational silos 4 times; they failed each time. Titan missiles have never been fired.

– There are between 80,000 and 100,000 artists (including designers) in New York City.

Born in Chicago, Illinois, 1947. Attended the University of Wisconsin, Madison (B.A. 1971); Cranbrook Academy of Art, Bloomfield Hills, Michigan (M.F.A. 1973). Lives in New York City.

SELECTED SOLO EXHIBITIONS

1974 – Contemporary Arts Foundation, Oklahoma City 1975 – Everson Museum, Syracuse, NY 1977 – *Gathering Dust: Sorting,* Delahunty Gallery, Dallas, TX; *I-35,* Moore, OK 1978 – Anthology Film Archives, New York; Artists Space, New York; Western Michigan University, Kalamazoo, MI 1979 – Anthology Film Archives, New York; *Projects: Donald Lipski,* Museum of Modern Art, New York; Tangeman Fine Arts Gallery, University of Cincinnati, OH 1980 – Delahunty Gallery, Dallas, TX; Eaton/Shoen Gallery, San Francisco, CA; *Focus: Donald Lipski,* Fort Worth Art Museum, TX; *Gathering Dust: Comparing,* Pittsburgh Art Center, PA; Open Gallery, Eugene, OR 1981 – Braathen-Gallozzi Gallery, New York; Triton Art Museum, Santa Clara, CA 1982 – Portland Center for the Visual Arts, OR; Turnbull, Lutjeans, Kogan Gallery, Newport Beach, CA 1983 – Galleriet, Lund, Sweden; Germans Van Eck Gallery, New York

SELECTED GROUP EXHIBITIONS

1972 – *The 59th Exhibition for Michigan Artists,* Detroit Institute of Art, MI 1973 –

Beaux Arts Designer Craftsmen Exhibition, Columbus Museum of Art, OH 1974 – *Non-Coastal Flatlands Sculpture Show*, Wichita Art Museum, KA 1977 – *Tenth International Encounter on Video*, Mexico City (exh. cat.) 1978 – *Atlanta Independent Film and Video Festival*, High Museum of Art, Atlanta, GA; *Eleventh International Encounter on Video*, Sogetsu Kaikan Gallery, Tokyo, Japan (exh. cat.) 1979 – Pam Adler Gallery, New York; *Diamond, Lieberman, Lipski*, Root Art Center, Clinton, NY (exh. cat.; text by William Salzillo); *Sculptors' Photographs*, Hunter Gallery, New York (traveled) 1980 – *The Artists at Work in America*, Varna, Bulgaria; Braathen-Gallozzi Gallery, New York; *Seven Artists*, Neuberger Museum, State University of New York, Purchase (exh. cat.; text by Edit DeAk); *Tapes and Drawings*, Hunter Gallery, New York 1981 – *Art on the Beach*, Battery Park Landfill, New York; *Stay Tuned*, The New Museum, New York (exh. cat.; text by Ned Rifkin) 1982 – Aaron Berman Gallery, New York; Eaton/Shoen Gallery, San Francisco, CA 1983 – The American Academy and Institute of Arts and Letters, New York; Grace Borgenicht Gallery, New York; *Framed Space*, Harvard School of Art and Architecture, Cambridge, MA; *Language, Drama, Source and Vision*, The New Museum of Contemporary Art, New York; Margo Leavin Gallery, Los Angeles, CA

SELECTED BIBLIOGRAPHY

Articles and Reviews

Albright, Thomas. "San Francisco: Approximately 4,000 Small Sculptures," *Art News*, vol. 80, no. 1, January 1981, p. 77.
"Artists on Architecture," *Progressive Architecture*, September 1981, p. 49.
Ballatore, Sandy. "Sculpture Conferencing – A Personal Response," *Images and Issues*, November/December 1982, pp. 44-47.
Blau, Eleanor. "Artistic Video," *New York Times*, August 10, 1981, p. C12.
Cantrill, Arthur and Corrinne. "Mirror Replacement: An Interview with Donald Lipski," *Cantrill's Film Notes* [Melbourne, Australia], April 1975, flyleaf and pp. 23-26.
Cox, Cathy. "Scenes," *Village Voice*, vol. 23, no. 41, October 16, 1978, p. 18.
Foxx, Howard N. "The Thorny Issues of Temporary Art," *Museum News*, July/August 1979, p. 50.
Kinz, Lance. "Donald Lipski: Gathering Dust," *Dialog* [Akron, OH], November/December 1979, pp. 44-45.
Larson, Kay. "Art: Spring Cleaning," *New York Magazine*, March 30, 1981, p. 51.
Lee, Cecil. "Donald Lipski: Gathering Dust," *Criss Cross Art Communications* [Boulder, CO], vol. 5, February 1977, cover and pp. 2-7.
Levin, Kim. "Reviews," *Village Voice*, vol. 26, no. 13, March 18, 1981, centerfold and pp. 92, 94.

Marvel, Bill. "An Exhibit Where Small is Beautiful," *Dallas Times Herald*, March 19, 1980, Entertainment Section, pp. 1, 9.
Perlberg, Deborah. "Reviews," *Artforum*, vol. 17, no. 8, April 1979, pp. 67-68.
Perreault, John. "Reviews," *Soho Weekly News*, June 4, 1980, p. 58.
Phillips, Deborah. "New Faces in Alternative Spaces," *Art News*, vol. 80, no. 9, November 1981, p. 96.
Raynor, Vivien. "Lipski's 'Building Steam' Opens SoHo Gallery," *New York Times*, September 20, 1983, p. C20.
Sargent-Wooster, Ann. "Review," *Art in America*, vol. 69, no. 8, October 1981, pp. 146-47.
Stofflet, Mary. "Review," *Images and Issues*, November/December 1982, p. 68.
Wehrer, Anne. "San Francisco Art Scene," *Boulevards* [San Francisco], February 1981, pp. 40-41.
Wooster, Ann-Sargent. "Review," *Art in America*, vol. 69, October 1981, pp. 146-47.
Zimmer, William. "Small Art," *Soho Weekly News*, December 7, 1979, p. 31.

Artist's Writings

Kostelanetz, Richard, et. al. *Fifth Assembling*. New York: Assembling Press, 1974
McCarver, Beau, ed. *Volume I, Number I*. Norman, Oklahoma: MacCarver, 1974.
"The Mobile Ranch," *Criss Cross Communications* [Boulder, CO], vol. 1, no. 4, November 1976, pp. 14-19.

MELISSA MILLER

ARTIST'S STATEMENT

The paintings chosen for this exhibition are all from a series I called *Studies for the Ark*. They evolved from a particularly stormy (daily showers, flashfloods, and an occasional tornado watch) life period. I lost a few friends, but my dogs were always kind.

Painting for me has always been the merger of emotional expression and formal painterly concerns. Sometimes the two flow hand in hand, but more often in the process of making a painting, they battle it out to the end. As in life, a bit of tension makes things more interesting.

Born in Houston, Texas, 1951. Attended the University of Texas, Austin (1969–71); the Museum of Fine Arts School, Houston, Texas (1971); Yale Summer School of Music and Art, New Haven, Connecticut (1974); the University of New Mexico, Albuquerque (B.F.A. 1974). Lives in Austin, Texas.

SELECTED SOLO EXHIBITIONS

1978 – *Young Texas Artist Series,* Amarillo Art Center, TX (exh. cat.; text by Thomas S. Livesay) 1981 – *Perspective Series,* Contemporary Arts Museum, Houston, TX (exh. cat.; text by Linda L. Cathcart); Projects Gallery, Art Museum of South Texas, Corpus Christi 1983 – Texas Gallery, Houston

SELECTED GROUP EXHIBITIONS

1973 – A.S.A. Gallery, University of New Mexico, Albuquerque 1974 – *Southwest Fine Arts Biennial,* Museum of New Mexico, Santa Fe 1977 – *Painting and Sculpture Exhibition,* One Seguin Art Center, Seguin, TX; *Women and Their Work,* Laguna Gloria Art Museum, Austin, TX 1978 – Austin Contemporary Visual Arts Association, St. Edwards University, TX; *Works on Paper: Southwest 1978,* Dallas Museum of Fine Arts, TX 1979 – *The Amarillo Competition,* Amarillo Art Center, TX; *Austin Contemporary Art Exhibition,* Trinity House Gallery, TX; *New Works, Melissa Miller and Claudia Reese,* Laguna Gloria at First Federal, Austin, TX 1980 – *Introductions '80,* Robinson Galleries, Houston, TX; *1980 New Orleans Triennial,* New Orleans Museum of Art, LA (exh. cat.; text by William Fagaly, Marcia Tucker); *Texas Fine Arts Association (T.F.A.A.) 1980 Annual Exhibition,* Laguna Gloria Art Museum, Austin, TX; *Texas Only,* T.F.A.A. Summer Exhibition, Laguna Gloria Art Museum, Austin, TX; *Visions and Figurations,* California State University, Fullerton (exh. cat.; text by Rod Faulds,

Winnefred Oak) 1981 – *Longview Invitational 1981,* Longview Museum and Arts Center, TX; *Wendy Edwards and Melissa Miller,* Mattingly Baker Gallery, Dallas, TX 1982 – *New Works, Summer '82,* Laguna Gloria Art Museum, Austin, TX (exh. cat.; text by Annette Dimeo Carlozzi); Patrick Gallery, Austin, TX 1983 – *1983 Whitney Biennial,* Whitney Museum of American Art, New York (exh. cat.); *Certain Realities,* University Art Museum, University of New Mexico, Albuquerque (exh. cat.; text by Emily Kass); *Invitational Exhibition,* Bell Gallery, Brown University, Providence, RI (exh. cat.); *New Figurative Drawing in Texas,* San Antonio Art Institute, TX; *Southern Fictions,* Contemporary Arts Museum, Houston, TX (exh. cat.; text by William Fagaly, Monroe K. Spears); *Texas Images and Visions,* Archer M. Huntington Gallery, University of Texas at Austin

SELECTED BIBLIOGRAPHY

Articles and Reviews

Ashbery, John. "Biennials Bloom in the Spring," *Newsweek,* vol. 51, no. 16, April 18, 1983, pp. 93-4.

Bassin, Joan. "Art of the South," *Austin American-Statesman,* August 28, 1983, p. 37.

——. "Texan's Paintings Look Like Flowers Among Weeds of NYC Art," *Austin American-Statesman,* May 1, 1983, pp. 58-59.

Beal, Greg. "'New Works' Wrap You in Color," *Austin American-Statesman,* July 4, 1982, p. 33.

Cameron, Daniel. "Biennial Cycle," *Arts Magazine,* vol. 57, no. 10, June 1983, pp. 64-67.

Cone, Michèle. "The Whitney Biennial," *Flash Art,* Summer 1983, p. 62.

Crossley, Mimi. "Paintings by Melissa Miller," *Houston Post,* January 1, 1982, p. 6D.

Daviee, Jerry M. "Reviews: Lisa Baack, Carol Ivey, Melissa Miller at the Amarillo Art Center," *Artspace* [Albuquerque], Summer 1978.

Fox, Kevin. "Southern Fictions," *Dallas Downtown News,* August 14–18, 1983.

Freudenheim, Susan and Susie Kalil. "A Survey of Texas Art," *Arts and Architecture* [Los Angeles], vol. 1, no. 2, Winter 1981, pp. 26-27.

Freudenheim, Susan. "Uniting Art and Allegory: the Energetic Paintings of Melissa Miller," *Texas Homes* [Dallas], July 1982, vol. 6, no. 6, pp. 23-26.

Goetzmann, William F. "Images of Texas," *Artspace* [Albuquerque], vol. 7, no. 2, Spring 1983, pp. 20-25.

Green, Roger. "Southern Artists in Spotlight," *The Times Picayune / The States-Item* [New Orleans], October 3, 1980, pp. 6-7.

Heartney, Eleanor. "Pessimism Prevails Over Humanism in Whitney Biennial," *New Art Examiner,* vol. 10, no. 8, May 1983, pp. 10, 35.

Hoelterhoff, Manuela. "Whitney Double: No Blue Faces," *Wall Street Journal,* April 15, 1983.

Johnston, Patricia C. "Miller's Paintings Show Her Youth and Enthusiasm," *Houston Chronicle,* December 25, 1981, Sec. 5.

——. "The Enigma of the South," *Houston Chronicle,* August 7, 1983, p. 13.

Kalil, Susie. "Art: Southern Fictions," *Houston Post,* August 7, 1982, pp. 1, 7.

——. "Melissa Miller," *Art News,* vol. 81, no. 5, May 1982, p. 149.

Kutner, Janet. "In the Southern Tradition," *Dallas Morning News,* August 26, 1983, pp. C1, 3.

——. "Refracted 'Images'," *Dallas Morning News,* March 4, 1983, pp. C1-2.

Larson, Kay. "All-American Energy," *New York Magazine,* vol. 16, no. 15, April 11, 1983, pp. 61-63.

Marvel, Bill. "Gallery Hopping," *Dallas Times Herald,* June 10, 1981.

Neal, Patsy. "Figuratives Highly Imaginative," *San Antonio Light,* January 28, 1982, p. 31.

Russell, John. "It's Not Women's Art, It's Good Art," *New York Times,* July 24, 1983, Sec. 2, pp. 1, 25.

———. "Why the Latest Whitney Biennial Is More Satisfying," *New York Times,* March 25, 1983, pp. 15-16.

Sozanski, Edward J. "Annual Shows: Do We Really Need Them?," *Philadelphia Inquirer,* April 10, 1983.

Taliaferro, John. "Melissa's Ark," *Third Coast* [Austin], June 1982, pp. 64-67.

Vander Lee, Jana. "Texas Art, Hot and Heavy," *Artspace* [Albuquerque], vol. 6, no. 4, Fall 1982, pp. 8-10.

Wolff, Theodore F. "Let's Not Overlook the Breadth of American Art," *Christian-Science Monitor,* April 12, 1983, p. 18.

ROBERT MORRIS

Born in Kansas City, Missouri, 1931. Attended the Kansas City Art Institute, University of Kansas City, Missouri (1948–50); California School of Fine Arts, San Francisco (1950–51); Reed College, Portland, Oregon (1953–55); Hunter College, New York (M.A. 1963). Lives in New York City.

For Biographical and Bibliographical information prior to 1980, please refer to *Robert Morris Selected Works: 1970–1980* by Marti Mayo, Contemporary Arts Museum, Houston, Texas, 1980.

SELECTED SOLO EXHIBITIONS

1981 – *Robert Morris: Selected Works 1970–1980,* Contemporary Arts, Houston, TX
1982 – *The Drawings of Robert Morris,* Sterling and Francine Clark Art Institute, Williamstown, MA (traveled) 1983 – *Hypnerotomachia: Reliefs & Firestorm: Drawings,* Sonnabend Gallery, New York; *Psychomachia: Drawings,* Leo Castelli Gallery, New York

SELECTED GROUP EXHIBITIONS

1981 – *Painting and Sculpture by Candidates for Art Awards,* American Academy and Institute of Art and Letters, New York; *Selections from Castelli: Drawings and Works on Paper,* Neil G. Ovsey Gallery, Los Angeles, CA; *Leo Castelli Selects for Gloria Luria Gallery,* Gloria Luria Gallery, Bay Harbour Island, FL; *Working Drawings,* Hunter Gallery, New York; *New Dimensions in Drawing,* Aldrich Museum of Contemporary Art, Ridgefield, CT; *Schemes: A Decade of Installation Drawings,* Elise Meyer, Inc., New York (exh. cat.; traveled); *Internationale Ausstellung Köln 1981,* Cologne, West Germany; *Soundings,* The Neuberger Museum, State University of New York, Purchase, NY; *Varients: Drawings by Contemporary Sculptors,* Sewall Art Gallery, Texas; Art Museum of South Texas, Corpus Christi; *Small Works from the Past 15 Years,* The New Gallery of Contemporary Art, Cleveland, OH; *A Tradition Established 1940–70,* Whitney Museum of American Art, Fairfield County Branch, Stamford, CT; *Metaphor: New Projects by Contemporary Sculptors,* Hirschhorn Museum, Washington, D.C. (exh. cat.)
1982 – Tulane University, New Orleans, LA; *Antiform et Arte Povera, Sculptors 1966–69,* Centre d'Arts Plastiques Contemporains de Bordeaux, France; The High Museum of Art, Atlanta, GA; *Postminimalism,* The Aldrich Museum, Ridgefield, CT; *Castelli and his Artists: Twenty-five Years,* Leo Castelli Gallery, New York (traveled); *The Rebounding Surface,* Avery Center for the Visual Arts, The Bard College Center, Annandale-on-Hudson, NY; *Zeitgeist,* Martin Gropius Building, Berlin, West Germany; *Minimalism x 4,* Whitney Museum of American Art, Downtown Branch, New York (exh. cat.; text by Lauren Baker, Jennifer Dowd); *In Our Time,* Contemporary Arts Museum, Houston, TX

SELECTED BIBLIOGRAPHY

Articles and Reviews

Adcock, Craig. "The Big Bad: A Critical Comparison of Mount Rushmore and Modern Earthworks," *Arts Magazine,* vol. 57, no. 8, April 1983, pp. 104-107.

Cohen, Ronny. "Robert Morris at Leo Castelli and Sonnabend," *Art News,* vol. 82, no. 3, March 1983, p. 159.

Flood, Richard. "'Soundings', Neuberger Museum, State University of New York," *Artforum,* vol. 20, no. 9, May 1982, pp. 88-89.

Kahn, Barry. "Public Sculpture as Living Presence," *New Art Examiner,* vol. 9, no. 2, November 1981, pp. 1, 6-8.

Kalil, Susie. "Robert Morris: Provocative Visual Vocabularies," *Artweek,* vol. 13, no. 6, February 13, 1982.

Levin, Kim. "Robert Morris," *Village Voice,* January 25, 1983, p. 85.

Lichtenstein, Therese. "Robert Morris," *Arts Magazine,* vol. 57, no. 7, March 1983, pp. 40-41.

Marmer, Nancy. "Death in Black and White," *Art in America,* vol. 71, no. 3, March 1983, pp. 129-33.

Renard, Delphine. "Robert Morris, Galerie Daniel Templon," *Art Press* [Paris], July/August 1983, p. 54.

Rickey, Carrie. "Do You Think the End of the World will come at night or at dawn?," *Village Voice,* June 15, 1982, pp. 68-69.

Swift, Mary. "Metaphor: New Projects by Contemporary Sculptors," *Sculptors International,* vol. 1, no. 1, pp. 8-10.

Artist's Writings

"American Quartet," *Art in America,* vol. 69, no. 10, December 1981, pp. 93-105.

"Ambimedia Issue," *Chelsea 39,* no. 39, 1981, pp. 99-112.

BEVERLY NAIDUS

ARTIST'S STATEMENT

There are some days when fears of future calamity crowd your mind and you just can't see a way out of it. A nightmare of bombs falling, visions of distant mushroom clouds can set it off or just tuning into any days news report. But functioning with that kind of depression, fully warranted, mind you, will either numb you out or craze you into the "chicken little" syndrome. The latter panicked calling out of what everyone already knows or isn't willing to believe really isn't productive.

We can't escape death; it is the concept of mass death and the end of civilization as we know it or perhaps the species, that is so awesomely terrifying. In an effort to rationalize you think of the bogeymen who existed at other times in history. But no bogeyman – whether it be the plague, a natural disaster, or supernatural beasts seem quite so brutal and frightening as the number of man-created time bombs we live with today.

Accepting apocalyptic visions as the immovable, unchangeable fate of mankind and living for the moment is one solution. Everyone has the right to be an ostrich, but not everyone can enjoy that role or maintain it for long. You can sit there, griping and blaming others, seeing any action on your part as ineffective and worthless, and not see the point or the reason in taking any responsibility for what's going on. So you sit there and watch it happen. Hope that you'll be in New York City when it does and be among the first to go. What fun!

The only positive reaction to the apparently mindless self-destructive nature of the human race is to believe in the capacity of human beings to grow, change, become aware, act, and come together. Sometimes a truly successful art work can achieve that consciousness-raising. And we can hope that somehow, as the situation becomes more desperate, more folks will get inspired and provoked to communicate and act creatively to turn things around.

Born in Salem, Massachusetts, 1953. Attended Carleton College, Northfield, Minnesota (B.A. 1975); Nova Scotia College of Art and Design, Halifax, Nova Scotia, Canada (M.F.A. 1978). Lives in Brooklyn, New York.

SELECTED SOLO EXHIBITIONS

1977 – *Hanging up (some laundry),* Anna Leonowens Gallery, Halifax, Nova Scotia 1978 – *This Is Not A Test,* Anna Leonowens Gallery, Halifax, Nova Scotia [Audio Installation] 1979 – *Daily Reminder,* 22 Beaver Street, New York [Audio Installation] 1980 – *Apply Within,* Franklin Furnace, New York [Audio Installation] 1981 – *The Party's Over,* Printed Matter, New York [Window Installation]

SELECTED GROUP EXHIBITIONS

1974 – *Arts Awareness Project,* St. Paul Museum of Arts and Science, MN; Carleton College Gallery, Northfield, MN (also '75); Provincetown Workshop Gallery, MA (also '75) 1978 – *Marked Down,* Eyelevel Gallery, Halifax, Nova Scotia 1980 – *Issue-Social Strategies by Women Artists,* Institute of Contemporary Art, London, England (exh. cat.; text by Lucy R. Lippard 1981 – *Transformations-Women in Art – '70 – '80,* Feminist Art Institute, Art Expo '81, N.Y. Coliseum, New York (exh. cat.; text by Katherine Allen); *Scale-ing,* P.S. 122 Gallery, New York (exh. cat.; text by Gene Rasenburger); *Art & Ecological Issues,* 22 Wooster Street Gallery, New York; *Who's Laffin Now?,* Gallery 1199, New York; *The Future is Ours,* Arsenal Gallery, New York (exh. cat.; text by Sharon Gilbert) 1982 – *Carnival Knowledge,* The New School for Social Research, New York; *Nine Women Artists,* SUNY at Binghamton Gallery (exh. cat.; text by Josephine Gear); *Radical Humor,* Loeb Center Gallery, New York University, New York (traveled); *Joint Forces,* Brooklyn Museum, NY; *The Monument Redefined,* Gowanus Memorial Art Yard, Brooklyn, NY; *Heresies Magazine Benefit Exhibition,* Frank Marino Gallery, New York; *The N.O. Show,* 9th Street Gallery, New York 1983 – *Consumer Beware,* Women's Interart Center, New York; *Not For Sale,* El Bohio, New York; *Subculture,* Group Material, New York;

The Suburbia Show, ABC No Rio, New York

SELECTED BIBLIOGRAPHY

Articles and Reviews

Aminoff, J. "New York City's Other Art Circuit," *G7 Studio* [Italy], September/October 1979.

Coker, Gylbert. "Review," *Art in America,* vol. 68, no. 7, September 1980, pp. 125-26.

Ginsberg, Merle. "This Week," *Soho Weekly News,* March 5, 1980.

Lippard, Lucy R. "Review," *Artforum,* vol. 18, no. 10, Summer 1980, p. 81-82.

Paul, Susan. "Art & Politics, Strange Bedfellows...," *The Phoenix* [Boston], May 6, 1982.

Ross, Marcia. *CBC Radio,* Halifax, Nova Scotia, June 1978. [radio review]

Whitfield, Tony. "Review," *Fuse* [Canada], May 1980.

———. "Vigilance...," *Artforum,* vol. 19, no. 11, September 1980, p. 69.

Zimmer, William. "Through the Glass, Starkly," *Soho Weekly News,* May 6, 1981.

Artist's Writings and Other Published Works

"The Waiting Game," *Heresies,* Winter/Spring 1982.

"Uneasy Listening," self-published collection of audio works, 1981.

HELEN OJI

ARTIST'S STATEMENT

Erupting volcanoes are grandiose, mysterious, and yet so terrifying. This natural phenomenon has influenced our beliefs, superstitions, and legends. Recent events of erupting volcanoes, and being a fan of science-fiction films captivated my imagination, compelling me to do a series of new work.

The initial influence for the Volcano Series began in 1980. I did a painting of Mount St. Helens depicting an erupting volcano with a small running figure. The painting was executed on a kimono-shaped format, a format primarily used for seven years. Actual volcanic dust was used with bright acrylic pigments, rhoplex, glitter, and dimensional objects making a rich tactile painted surface.

My current charcoal and acrylic drawings are done as preparations for paintings. I began working towards a large rectangular format last April. Ideas needed to be worked out quickly as my paintings take some time to do. The drawings are animated; depicting erupting volcanoes, falling rocks with small figures near the site. Each figure has an undertone of humor, inspired by seeing Japanese science-fiction films. These ironic characters are taking their last glimpse of a volcano predicted to erupt, but are caught in the cataclysmic event. The scale of volcanoes and rocks are quite large in comparison to the figures, projecting the monumental aspect of volcanic activity.

My work is concerned with animation, change, and physical substance. Through imagery and gesture of materials, I want the work to envelop the viewer into its environment. In a psychological sense, the viewer is observing at a distance, becoming a helpless spectator. The volcano erupts – one is left to view the turbulence.

Born in Sacramento, California, 1950. Attended Yuba College, Marysville, California (A.A. 1970); California State University, Sacramento (B.A. 1972, M.A. 1975). Lives in New York City.

SELECTED SOLO EXHIBITIONS

1976 – Church Fine Arts Gallery, University of Nevada, Reno 1980 – Fine Arts Center, Wake Forest University, Winston-Salem, NC 1981 – Monique Knowlton Gallery, New York (also '82) 1982 – Nelson Gallery, University of California, Davis

SELECTED GROUP EXHIBITIONS

1974 – *Don Hazlitt / Helen Oji,* Artist Contemporary Gallery, Sacramento, CA 1975 – *Crocker-Kingsley Annual,* E.B. Crocker Art Gallery, Sacramento, CA 1976 – *Contemporary Asian Artists,* Art Gallery, California State University, Sacramento 1977 – *Whitney Counterweight,* Auction 393, New York 1978 – *Serial Drawing,* Hera Women's Cooperative Gallery, Wakefield, RI; Soho Center for the Visual Arts, New York 1980 – *Contemporary Glitter,* Kathryn Markel Fine Arts, Inc., New York; *New Imagists,* The Alternative Museum, New York; *62x12,* The Drawing Center, New York; *Small Works,* 80 Washington Square East Galleries, New York University, New York 1981 – *New Art II: Surfaces and Textures,* Penthouse Gallery, Museum of Modern Art, New York; *A New Bestiary: Animal Imagery in Contemporary Art,* Institute of Contemporary Art of the Virginia Museum, Richmond (exh. cat.; text by Julia Boyd); *Art as Object,* Semaphore Gallery, New York 1982 – *Art Across the Park,* Central Park, New York; *New Drawing in America,* The Drawing Center, New York (exh. cat.; text by Martha Bech, Marie Keller); *Artifacts and Objects of Devotion,* The Alternative Museum, New York 1983 – *A Letter from*

New York, Sheppard Gallery, University of Nevada, Reno; *Hong Kong, Tokyo, New York,* Kenkeleba Gallery, New York; *Peachfish,* Basement Workshop, New York [installation/performance collaboration]

SELECTED BIBLIOGRAPHY

Articles and Reviews

Cohen, Ronny. "Reviews," *Artforum,* vol. 21, no. 5, January 1983, p. 74.

Larson, Kay. "Small Talk," *Village Voice,* February 11, 1980, p. 74.
——. "Talkin' 'Bout My Generation," *Village Voice,* June 18, 1980, p. 73.
——. "Fresh Air Fun," *New York Magazine,* vol. 15, August 16, 1982, p. 54.
Perreault, John. "Review," *Soho Weekly News,* June 18, 1980, p. 29.
Sargent-Wooster, Ann. "Art Reviews," *Art in America,* vol. 71, no. 1, January 1983, pp. 124-26.

Zimmer, William. "Small Victory," *Soho Weekly News,* February 13, 1980.
——. "62 Drawings by 12 Artists," *Soho Weekly News,* May 14, 1980, p. 54.
——. "Art Breakers/NY's Emerging Artists," *Soho Weekly News,* September 17, 1980, special supplement, p. 36.
——. "Review," *Art Gallery Scene,* October 30, 1982, p. 25.

JAMES POAG

ARTIST'S STATEMENT

A recurring theme in my work is the conflict between man and nature. I see this struggle as central to our predicament in these times – man's effort to conquer a physical world over which he has no control. This then becomes a metaphor for man's conflict between his rational and irrational selves.

These paintings are specific statements that evolve from my everyday experience. I attempt to deal with the particulars of my own existence in such a way that they become universal.

Born in Columbia, Tennessee, 1954. Attended the Middle Tennessee State University (B.F.A. 1977); University of Houston (M.F.A. 1982). Lives in Houston, Texas.

SELECTED SOLO EXHIBITIONS

1983 – *Jim Poag: Recent Work,* Center for Art and Performance, Houston, TX

SELECTED GROUP EXHIBITIONS

1980 – *From Lawndale – Four Painters,* The Lawndale Annex of the University of Houston, TX 1981 – *Exchanges,* Maryland Institute – Art Institute of Chicago/University of Houston (traveled); *First Annual Galveston Invitational Exhibition,* Galveston Art Center, TX; *The Image of the House in Contemporary Art,* The Lawndale Annex of the University of Houston, TX (exh. cat.) 1982 – *Art from Houston in Norway,* Stavanger Kunstforening, Stavanger, Norway (exh. cat.; traveled); *James Poag/Jeff DeLude,* Lawrence Oliver Gallery, Philadelphia, PA; *Texas on Paper,* Contemporary Arts Museum, Houston, TX (exh. cat.; traveled); *13 Artists – A Look At Houston,* Georgia State University, Atlanta

SELECTED BIBLIOGRAPHY

Articles and Reviews

Crossley, Mimi. "Art: Texas on Paper," *Houston Post,* February 21, 1982.
Sachs, Sid. "Jeff DeLude, Jim Poag," *New Art Examiner,* October 1982, p. 17.

KATHERINE PORTER

ARTIST'S STATEMENT

Visions of the apocalypse are symbolic of the darkness within us; the conflict of good and evil, the very physical manifestations of the consequences of evil, and of the terrifying chaos and turbulence in nature. Retributions as restorative. But retribution is a human invention for our never ending struggle, the conflict of good and evil resolved in nature. The possibility of resolution – man *with* nature is what I believe in – the writings of Camus, Teilhard de Chardin, Thomas Berry, on our responsibility and brighter future.

Born in Cedar Rapids, Iowa, 1941. Attended Boston University, Massachusetts (1962); Colorado College, Colorado Springs (B.A. 1963); Colby College, Waterville, Maine (Honorary Degree 1982). Lives in Belfast, Maine.

SELECTED SOLO EXHIBITIONS

1971 – Main Gallery, University of Rhode Island, Kingston; Parker 470 Gallery, Boston, MA 1972 – Henri Gallery, Washington, D.C. 1973 – Worcester Art Museum, MA 1974 – Hayden Gallery, Massachusetts Institute of Technology, Cambridge (exh. cat.; text by Wayne Anderson) 1975 – David McKee Gallery, New York (also '78, '79, '81, '82) 1976 – Harcus Krakow Gallery, Boston, MA 1980 – *Katherine Porter: Works on Paper 1969 – 79*, California Palace of Legion of Honor, Fine Arts Museum of San Francisco, CA (exh. cat.; traveled) 1981 – Hood Museum of Art, Dartmouth College, Hanover, NH 1983 – Arts Club of Chicago, IL; Beaver College, Glenside, PA

SELECTED GROUP EXHIBITIONS

1967 – *Betty Parsons Collection*, Finch College, New York 1969 – *Collaboration*, Institute of Contemporary Art, Boston, MA; *Insights*, Parker 470 Gallery, Boston, MA; *1969 Whitney Annual*, Whitney Museum of American Art, New York (exh. cat.) 1970 – *Six Artists*, Hayden Gallery, Massachusetts Institute of Technology, Cambridge; *Drawings Re-examined*, Institute of Contemporary Art, Boston, MA 1972 – *Twelve from Around Town*, Thayer Academy, Braintree, MA; *Boston Collects Boston*, Museum of Fine Arts, Boston, MA 1973 – *1973 Whitney Biennial*, Whitney Museum of American Art, New York (exh. cat.); *Six Visions*, Institute of Contemporary Art, University of Pennsylvania, Philadelphia (exh. cat.; text by Susan Delahunty) 1977 – *From Women's Eyes*, Rose Art Museum, Brandeis University, Waltham, MA (exh. cat.; text by Bonnie Saunier); *Nine Artists: Theodoron Awards*, Solomon R. Guggenheim Museum, New York (exh. cat.) 1978 – *Spoleto Choice*, Spoleto Festival U.S.A., Charleston, SC; *Recent Acquisitions: H.H.K. Foundation for Contemporary Art*, Milwaukee Art Center, WI; *Drawings*, Makler Gallery, Philadelphia, PA 1979 – *New York – A Selection from the Last 10 Years*, Otis Art Institute, Los Angeles, CA (exh. cat.; text by Betty Parsons); *New Options in Painterly Abstraction*, Cadman Plaza, Brooklyn, NY (exh. cat.; text by Michael Phillips); *Drawing Now*, Impressions Gallery, Boston, MA; Alpha Gallery, Boston, MA 1980 – *Winter Olympics*, Lake Placid, NY; *Painterly Abstraction*, Brockton Art Museum, MA 981 – *1981 Whitney Biennial*, Whitney Museum of American Art, New York (exh. cat.); *Abstract Mythologies*, Nina Nielsen Gallery, Boston, MA 1982 – *Currents: A New Mannerism (Part II)*, Jacksonville Art Museum, FL (exh. cat.; text by Margaret Miller); *74th American Exhibition*, Art Institute of Chicago, IL (exh. cat.); *The Abstract Image*, Hamilton Gallery, New York 1983 – *Homage to Arthur Dove*, Hobart and William Smith Colleges, Geneva, NY; *Six Painters*, Hudson River Museum, Yonkers, NY (exh. cat.; text by Peter Langlykke); *20 New York Painters*, Institute of Contemporary Art, University of Pennsylvania, Philadelphia

SELECTED BIBLIOGRAPHY

Articles and Reviews

Allara, Pamela. "Boston: Shedding its Inferiority Complex," *Art News*, vol. 78, no. 9, November 1979, pp. 98-105.

Arghyros, Nan. "Katherine Porter, Painter," *New Boston Review*, June 1975.

Buonagurio, Edgar. "Review," *Arts Magazine*, vol. 54, no. 1, September 1979.

Foster, Hal. "Katherine Porter," *Artforum*, vol. 19, no. 3, November 1980, p. 85.

Frackman, Noel. "Review," *Arts Magazine*, vol. 50, no. 5, January 1976, pp. 19-20.

Frank, Peter. "Review," *Art News*, vol. 75, no. 2, February 1976, p. 120.

Kramer, Hilton. "A Strategy for Viewing the Biennial," *New York Times*, February 27, 1981.

Morch, Al. "An Artist Who Keeps Growing," *San Francisco Examiner*, March 3, 1980, p. 29.

Moss, Stacey. "Review," *Art in America*, vol. 64, no. 3, May/June 1976, pp. 113-14.

O'Beil, Hedy. "Review," *Arts Magazine*, vol. 53, no. 10, June 1979, p. 21.

Raynor, Vivian. "Review," *New York Times*, March 18, 1978.

Ross, Laura. "Depth Beyond the Surface," *Vision*, September/October/November 1979.

Russell, John. "Juicy Abstractions by Katherine Porter," *New York Times*, February 27, 1981.

Sargent-Wooster, Ann. "Review," *Artforum*, vol. 14, no. 6, February 1976, p. 61.

Schjeldahl, Peter. "Review," *Artforum*, vol. 27, Summer 1979, pp. 63-64.

Shirey, David L. "An Exhibition in Praise of Paper," *New York Times*, May 13, 1979.

Simon, Joan. "Expressionism Today: An Artists Symposium," *Art in America*, vol. 70, December 1982, pp. 73-74.

Storr, Robert. "Katherine Porter at David McKee," *Art in America*, vol. 71, no. 5, May 1983, pp. 166-67.

Tomkins, Calvin. "Three Salons," *New Yorker*, April 13, 1981, pp. 112-16.

Westfall, Stephen. "Katherine Porter," *Arts Magazine*, vol. 55, no. 10, June 1981, pp. 25-26.

――. "Review," *Arts Magazine*, vol. 57, no. 6, February 1983, p. 39.

Yau, John. "Review," *Art in America*, vol. 67, no. 8, December 1979, p. 118.

Books

Lucie-Smith, Edward. *Art in the Seventies*. Oxford, England: Phaidon Press, Ltd., 1980, illus., pp. 44-45.

CRAIG SCHLATTMAN

ARTIST'S STATEMENT

Although the scientific aspect of this work is intended to lend a credulity to these impossible experiments, it's also a visual response to language, a sort of "linguistic imagery." The language of science can have as much visual response as poetry or prose. Some of the titles read as they would from a physics book, some are as fictional as the experiments, but sound authentic.

Admittedly tongue in cheek, the execution, approach, and concerns are serious.

Born in St. Paul, Minnesota, 1949. Attended the University of Minnesota (B.F.A. 1979); California Institute of the Arts, Valencia (M.F.A. 1981). Lives in Santa Monica, California.

SELECTED SOLO EXHIBITIONS

1980 – California Institute of the Arts, Valencia (also '81) 1982 – California State University at Long Beach; *8 x 10 Show,* Susan Spiritus Gallery, Newport Beach, CA

SELECTED GROUP EXHIBITIONS

1979 – *Film Expo,* Minneapolis, MN; *Cream of Wheat Show,* West Bank Gallery, Minneapolis, MN 1981 – California Institute of the Arts, Valencia; J. Paul Getty Museum, Malibu, CA; *10th Annual Cal Arts Photo Contest,* California Institute of the Arts, Valencia; *Print Auction,* BC Space, Laguna Beach, CA (exh. cat.) 1983 – *Chuck Nicholson / Larkin Maureen Higging / Craig Schlattman,* BC Space, Laguna Beach, CA

SELECTED BIBLIOGRAPHY

Articles and Reviews

Bellon, Linda. "3 SoCal Contemporaries," *Artweek,* vol. 14, no. 31, September 24, 1983.

MICHAEL SMITH

ARTIST'S STATEMENT

GOVERNMENT APPROVED HOME FALLOUT SHELTER/SNACK BAR

Mike, a model citizen, had been reading about spills, thrills and increased military spending. He thought perhaps he should prepare for when the "Big One" drops. After some inquiry, he received plans for various home fallout shelters from his local Federal Emergency Management Agency (FEMA) office. Plan D, Home Fallout Shelter/Snack Bar, perfectly suited his needs. For as long as he could remember he wanted to redo the rec room, so why not pay pound for pound attention to the new addition? Even though the expense was more than he bargained for, Mike quickly dismissed any hesitation when figuring this snack bar bunker would last a lifetime.

Since 1979, any citizen requesting information on civil defense practices during a nuclear disaster from FEMA would receive a 68 page pamphlet titled, "Protection in the Nuclear Age." Even though the pamphlet was printed in 1977, by 1979, most of its information was outdated and inaccurate. Eventually the U.S. printing office ran out of pamphlets and distribution of "Protection in the Nuclear Age" was discontinued in 1983.

Presently FEMA's "implementation strategy" for 1983 – 84, "to address the full spectrum of *potential* disaster situations the nation faces," is in effect. Now, any citizen can stay abreast of civil defense procedures by requesting the pamphlet, "In Time of Emergency." Everything one needs to know about nuclear catastrophe is concisely stated in the last nine pages of the updated edition. It is reassuring to know that our government has been constantly reevaluating its civil defense program and keeping their citizens informed.

Born in Chicago, Illinois, 1951. Attended Whitney Museum Independent Study Program (1970, 1973); Colorado College, Colorado Springs. Lives in New York City.

SELECTED SOLO PERFORMANCES AND VIDEO SCREENINGS

1975 – Artist's Studio, Chicago (also '76, '77), School of Art, University of Michigan, Ann Arbor 1976 – Artists Space, New York (also '77, '78); Collective for Living Cinema, New York; Franklin Furnace, New York (also '78) 1977 – La Jolla Museum of Contemporary Art, CA; N.A.M.E. Gallery, Chicago, IL (also '78) 1978 – California Institute of the Arts, Valencia; Hallwalls, Buffalo, NY; The Kitchen, New York; University of California, San Diego 1979 – Baltimore Museum of Art, MD; Colorado College, Colorado Springs; D.C. Space, Washington, D.C.; 80 Langton Street, San Francisco, CA; F.A.R. Inc., Los Angeles, CA; Kansas City Art Institute, KS 1980 – BF/VF, Boston, MA; Castelli Graphics,

New York [video]; The Gap, Toronto, Canada 1981 – Eaton/Shoen Gallery, San Francisco, CA; L.A.C.E., Los Angeles, CA; The Performing Garage, New York; Portland Center for Visual Arts, OR; Western Front, Vancouver, B.C. 1982 – Allen Memorial Art Museum, Oberlin College, OH; *The Dirty Show*, Franklin Furnace, New York; Hallwalls, Buffalo, NY; La Mamelle, San Francisco, CA; *Mike's House*, Whitney Museum of American Art, New York [installation with video] (traveled); Santa Barbara Contemporary Arts Forum, CA 1983 – *Government Approved Home Fallout Shelter Snack Bar*, Castelli Graphics, New York (with Alan Herman); ICC, Antwerp, Belgium; *Video Viewpoint Series*, Museum of Modern Art, New York [lecture, screening]; *Bill Loman, Master Salesman, Part I*, The Kitchen, New York; The New Gallery of Contemporary Art, Cleveland, OH

SELECTED GROUP PERFORMANCES, EXHIBITIONS, AND VIDEO SCREENINGS

1976 – *Performances: Four Evenings, Four Days*, Whitney Museum of American Art, New York 1977 – *Grommets #4*, Grommets Theater, New York; *Notebooks/Workbooks/ Scripts/Scores*, Franklin Furnace, New York; *A Sound Selection: Audio Works by Artists*, Artists Space, New York (exh. cat.; text by Barry Rosenthal; traveled) 1978 – *Expo '78*, Institute of Contemporary Art, University of Pennsylvania, Philadelphia; *Party Club Performance Cabaret*, Franklin Furnace, New York; Sidewalk, Inc., Hartford, CT; *Theatre Experiments in SoHo, Festival 2*, The Open Space, New York 1979 – *Artists Notebooks*, Kansas City Art Institute, KS; *Chicago Artists Perform*, Museum of Contemporary Art, Chicago, IL; *Groninger Zomermanifestatie 1979*, Kattebak Theater, Groningen, Holland (exh. cat.); *Midway Between Comedy and Art*, Midway Studios, University of Chicago,

IL 1980 – *April Benefit Month*, Hallwalls, Buffalo, NY; *Family Entertainment*, The Kitchen, New York; *Likely Stories*, Castelli Graphics, New York; Mudd Club, New York; *San Francisco Video Festival '80*, CA; *Times Square Show*, 201-5 West 41st Street, New York 1981 – *Artists Television Network*, MCTV, New York; *Fifth Annual Atlanta Independent Film and Video Festival*, GA; *Funny Video Tapes*, Institute for Art and Urban Resources at P.S. 1, Long Island City, NY; *Love is Blind*, Castelli Graphics, New York; *SoHo TV Presents*, Long Beach Museum of Art, CA; *Three Tape Comedians*, The Kitchen, New York; University Art Museum, University of California, Berkeley; *Not Just for Laughs*, The New Museum, New York (exh. cat.; text by Marcia Tucker) 1982 – *Art and the Media*, Renaissance Society, Chicago, IL (exh. cat.; text by Tom Lawson); *Atlanta Independent Film and Video Festival*, GA; CAPS Traveling Video Festival; *The New Narrative*, Global Village, New York; *New TV New York*, Long Beach Museum of Art, CA; *Reading Video*, Museum of Modern Art, New York; *TV Comedy*, Media Studies, Buffalo, NY (exh. cat.; text by John Minkowsky; traveled) 1983 – Contemporary Art Center, New Orleans, LA; *Funny/Strange*, Institute of Contemporary Art, Boston, MA [performance and video]; *3-D Photographs*, Castelli Graphics, New York; *Urban Pulses*, Pittsburgh Center for the Arts, PA; U.S. Film/Video Festival, Utah; *Video As Attitude*, University Art Museum, University of Albuquerque, NM (exh. cat.; text by Patrick Clancey, John Hanhardt)

SELECTED BIBLIOGRAPHY

Articles and Reviews

Bogosian, Eric. "Art World Underground," *The Drama Review*, vol. 84, pp. 31-36.

Burnside, Madeleine. "Hi, Toaster!," *Soho Weekly News*, October 28, 1976, pp. 27, 43.

Campbell, R.M. "Mr. Smith Comes to Washington," *Seattle Post Examiner*, April 6, 1981.

Carroll, Noel. "Gallery Humor," *Soho Weekly News*, February 2, 1978, p. 27.

Cook, Scott. "New York Reviews: Michael Smith at the Whitney Museum," *Art in America*, vol. 70, no. 5, May 1982, pp. 141-42.

Crowley, Tim. "Performance Review," *New Art Examiner*, January 1976, pp. 4-15.

Determeyer, Eddy. "Kunst; Michael Smith Steelt de Show," *Niew* [Holland], August 27, 1979.

Early, Michael. "Riot Acts," *Live Magazine*, vol. 7, no. 6, April 1982, pp. 32-35.

Frank, Peter. "Performance Diary," *Soho Weekly News*, March 18, 1979, pp. 22-23, 34.

Hoberman, J. "'Einstein Off the Beach," *Village Voice*, vol. 25, no. 42, October 22, 1980, p. 52.

Hochschild, Rosemary. "A Child is Being Beaten (by Someone Shorter Than Him)," *Bomb*, vol. 1, no. 2, 1982, pp. 7-9.

Howell, John. "Acting/Non-Acting," *Performance Art Magazine*, no. 2, 1979, pp. 7-18.

Larson, Kay. "Art," *New York Magazine*, June 27, 1983.

Lawson, Tom. "New York: December," *Real Life Maggazine*, no. 1, March 1979, p. 31.

Levi, Kim. "Doing the Laundry After World War III," *Village Voice*, June 7, 1983, p. 78.

Mandel, Howard. "Scanlines: Interactive Fable," *American Film*, vol. 7, no. 8, July – August 1982, p. 20.

———. "Give Me Shelter," *Video Games*, vol. 1, no. 11, August 1983.

Martin, Antoinette. "UTC Seen Piqued by Art Series," *Hartford Courant*, August 3, 1978, pp. 1, 12.

Ross, R.H. "Performance Artist Mixes Art, Humor with Skill," *News-Press* [Santa Barbara, CA], May 1, 1982, p. C33.

Stofflet, Mary. "Video: San Francisco," *Artweek*, vol. 11, no. 7, November 8, 1980, p. 3.

Tamblyn, Christine. "Chicago Performance: An Annotated Guide," *High Per-formance*, vol. 5, no. 1, Spring/Summer 1982, pp. 26-27.

Artist's Writings

80 Langton Street, June 1978 – May 1979, San Francisco: 80 Langton Street, 1980 (statement).

"Finding a Shirt," *Irrawaddy* [Düsseldorf], 1981.

"Secret Horror," *Egon* [Düsseldorf], no. 1, 1980, pp. 44-55.

With C.A. Klonarides. "Le Car," *High Per-formance*, vol. 4 – 2, no. 4, Summer 1981, p. 78.

With Van Lagestein. "The Big Relay Race," *FILE*, vol. 4, no. 4, Fall 1980, pp. 34-39. Reprinted as artist's book by Chicago Books, 1981.

With Van Lagestein. "Mike dans: what the," *FILE*, vol. 4, no. 3, Summer 1980, back cover.

With Van Lagestein. "What Should I Do About the Car?", *Real Life Magazine*, Winter, 1980, pp. 14-15.

ALAN HERMAN

Born in New York City, 1944. Attended Philadelphia College of Art, Pennsylvania (B.F.A. 1966); Tyler School of Art, Temple University, Philadelphia, Pennsylvania (M.F.A. 1968). Lives in New York City.

SELECTED SOLO EXHIBITIONS

1970 – Gallery 84, New York 1978 – O.K. Harris Works of Art, New York (also '81) 1979 – Diane Villani, New York; Institute for Art and Urban Resources at P.S. 1, Long Island City, NY 1982 – Berkshire Community College, Pittsfield, MA 1983 – *Government Approved Fallout Shelter Snack Bar*, Castelli Graphics, New York (collaboration with Michael Smith)

SELECTED GROUP EXHIBITIONS

1979 – Summit Art Center, NJ; *Small Works*, 80 Washington Square East Galleries, New York University, New York; Zolla Lieberman, Chicago, IL 1980 – Barbara Gladstone Gallery, New York; *Small Works*, 80 Washington Square East Galleries, New York University, New York; Visual Arts Gallery, Florida International University, Miami 1981 – *Combinations*, Empire Safe Company, New York; *The Constructed Image*, Rockland Center for the Arts, NY; Getler/Pall Gallery, New York; *Moonlighting*, Josef Gallery, New York; *Ward's Island Outdoor Sculpture Show*, New York

NANCY SPERO

ARTIST'S STATEMENT

I started to do the war series in 1966. The Vietnam War was going on...I had to re-think what I was doing as an artist. So I started thinking about the Vietnam War as content for the work. And at first I started doing atom bombs...total destruction. What happened was this terrific outburst – that the bombs became very sexual and very phallic. Mostly male bombs – a long penis with heads (with their tongues stuck out) at the end of the penis. Something that was once again unacceptable art! On the top of the bomb cloud there were heads spewing out poison or vomiting or sticking their tongues out. It all got really violent; the implication of sex and the power of the military, the power of a country having the atom bomb. But it had to do with male power.

Excerpted from *PROFILE*, vol. 3, no. 1, January 1983.

Born in Cleveland, Ohio, 1926. Attended Art Institute of Chicago (B.F.A. 1949); Atelier Andre L'Hote, Paris (1949–50), Ecole des Beaux-Arts, Paris (1949–50). Lives in New York City.

SELECTED SOLO EXHIBITIONS

1951 – Leonard Linn Gallery, Winnetka, IL 1954 – M. Singer and Sons Gallery, Chicago, IL 1959 – Rockford College, IL 1962 – Galerie Breteau, Paris, France (also '65, '68) 1971 – University of Califor-

nia at San Diego; Mombaccus Art Center, New Paltz, NY 1973 – *Codex Artaud*, A.I.R. Gallery, New York 1974 – Douglass College Library, Rutgers University, New Brunswick, NJ; *The Hours of the Night*, and *Torture in Chile*, A.I.R. Gallery, New York; Williams College Women's Center, Williams College, MA 1976 – *Torture of Women*, A.I.R. Gallery, New York 1977 – Marianne Deson Gallery, Chicago, IL 1978 – Herter Gallery, University of Massachusetts, Amherst; The Woman's Building, Los Angeles, CA 1979 – *Notes in Time on Women*, A.I.R. Gallery, New York; Real Art Ways, Hartford, CT 1980 – Livingston Gallery, Rutgers University, New Brunswick, NJ; Picker Art Gallery, Colgate University, Hamilton, NY 1981 – Ben Shahn Gallery, William Paterson College, Wayne, NJ; *The First Language*, A.I.R. Gallery, NY 1982 – Galerie France Morin, Montreal, Canada 1983 – Art Galaxy, New York; *Black Paintings, Paris, 1959 – 64*, and *Codex Artaud, 1971 – 72*, A.I.R. Gallery, New York; Matrix Gallery, Wadsworth Atheneum, Hartford, CT; *War Series*, Gallery 345 / Art for Social Changes Inc., New York

SELECTED GROUP EXHIBITIONS

1948 – Bordelon Gallery, Chicago, IL; *Exhibition Momentum*, Chicago, IL (annually, through '58) 1949 – Evanston Arts Center, IL 1950 – *61st Exposition des Artists Independents*, Grand Palais des Champs-Elysées, Paris, France (exh. cat.); University of Manitoba, Canada 1951 – Des Moines Art Center, IA; Northwestern University, Evanston, IL 1952 – Kerrigan-Hendricks Gallery, Chicago, IL; Renaissance Society, University of Chicago, IL 1955 – Cliffdwellers Art Gallery, Chicago, IL 1958 – *Nancy Spero / Leon Golub*, Indiana University, Bloomington 1962 – *Resurgence*, Galerie Breteau, Paris, France 1963 – *1er Salon International de Galeries Pilotes*, Musée Cantonal des Beaux-Arts, Lausanne, Switzerland (exh. cat.); *Le Dessin*, Galerie Breteau, Paris, France; *Realities Nouvelles*, Musee d'Art Moderne, Paris, France 1964 – *Huit Américains de Paris*, American Cultural Center, Paris, France (exh. cat.) 1965 – Los Angeles Peace Tower, CA 1967 – *Collage of Indignation I: Angry Arts*, New York University, New York 1969 – *II Biennial Internacional Del Deporte en las Bellas Artes*, Madrid, Spain; *Viewpoints II*, Colgate University, Hamilton, NY 1970 – *Flag Show*, Judson Memorial Church, New York; *Mod Donn Art*, Public Theater, New York (exh. cat.) 1977 – *Collage of Indignation II*, New York Cultural Center, New York 1972 – *American Woman Artists Show*, Gedok-Kunsthaus, Hamburg, West Germany; *Unmanly Art*, Suffolk Museum, Stony Brook, NY; *Women in the Arts*, C.W. Post Campus of Long Island University, NY 1973 – *Women Choose Women*, New York Cultural Center, New York (exh. cat.) 1974 – *In Her Own Image*, Philadelphia Museum of Art, PA 1976 – *Drawing Now: 10 Artists*, Soho Center for Visual Arts, New York (exh. cat.; text by Corinne Robins); *Visions: Distinguished Alumni 1945 to the Present*, Art Institute of Chicago, IL 1977 – *Radical Attitudes to the Gallery*, ART NET Ltd., London, England; *Solidarity with Chilean Democracy: A Memorial to Orlando Letelier*, Cayman Gallery, New York; *What is Feminist Art?*, The Woman's Building, Los Angeles, CA; *Words at Liberty*, Museum of Contemporary Art, Chicago, IL 1978 – *Overview, A.I.R. Retrospective*, Institute for Art and Urban Resources at P.S. 1, Long Island City, NY 1979 – *Artists Draw*, Artists Space, New York; *Centennial Exhibition*, Art Institute of Chicago, IL; Feministische Kunst Internationaal Haague Gemeentemuseum, The Hague, Netherlands (traveled); *Words and Images*, Philadelphia College of Art, PA (exh. cat.; text by Paula Marincola) 1980 – *Art of Conscience: The Art of the Last Decade*, Wright State University, OH (exh. cat.; text by Donald B. Kuspit; traveled); *Issue – Social Strategies by Women Artists*, Institute for Contemporary Art, London, England (exh. cat.; text by Lucy R. Lippard) 1981 – *Crimes of Compassion*, Chrysler Museum, Norfolk, VA (exh. cat.; text by Thomas Styron); *Messages*, Freedman Gallery, Albright College, Reading, PA (traveled); *Six Feminist Artists*, The Center for the Arts, Muhlenberg College, Allentown, PA 1982 – *Angry Art*, Basement Workshop, New York; *Beyond Aesthetics: Art of Necessity*, Henry Street Settlement, New York; *Dangerous Works*, Parsons School of Design, New York; *Mixing Art and Politics*, Randolph Street Gallery, Chicago, IL; *The Atomic Salon*, Ronald Feldman Gallery, New York 1983 – *Art Couples III, Nancy Spero, Leon Golub*, Institute for Art and Urban Resources at P.S. 1, Long Island City, NY; *Nancy Spero / Leon Golub*, Florence Wilcox Gallery, Swarthmore College, PA; *State of the Art, The New School Commentary*, Barbara Gladstone Gallery, New York; *The Revolutionary Power of Women's Laughter*, Protetch-McNeil Gallery, New York; *The War Show*, Fine Arts Center, SUNY at Stony Brook, NY; *Walls of the 70's*, Queensborough Community College, New York (exh. cat.; text by Corinne Robins; traveled); *What Artists Have to Say About Nuclear War*, Nexus Gallery, Atlanta, GA

SELECTED BIBLIOGRAPHY

Articles and Reviews

Alloway, Lawrence. "Art," *The Nation*, April 2, 1973.
——. "Art," *The Nation*, September 25, 1976.
——. "Nancy Spero," *Artforum*, vol. 14,

no. 9, May 1976, pp. 52-53.
———. "Women's Art in the 70's," *Art in America,* vol. 64, no. 3, May/June 1976, pp. 64-72.
Dallier, Aline. "L'image de la violence dans l'art des femmes," *Les Cahiers du Grif,* no. 14/15, December 1976.
de Pasquale, Carol. "Dialogues with Nancy Spero, *Womanart,* vol. 1, no. 3, Winter/Spring 1977, pp. 8-11.
———. *The Art Work of Nancy Spero,* Master's Thesis, Hunter College, CUNY, 1977.
Golub, Leon. "Bombs and Helicopters: The Art of Nancy Spero," *Caterpillar 1,* October 1967, pp. 46-53.
Guthrie, Derek. "Art Politics and Ethics," *New Art Examiner,* vol. 4, no. 7, April 1977, pp. 6-7.
Hamm, Donna. "Nancy Spero," *Dialogue,* March/April 1980, p. 44.
Horsfield, Kate. "Interview with Nancy Spero," *Profile,* vol. 3, no. 1, January 1983.
Kuspit, Donald B. "Nancy Spero," *Art in America,* vol. 63, July/August 1975, pp. 99-100.

———. "Spero's Apocalypse," *Artforum,* vol. 18, April 1980, pp. 34-35.
Landry, Pierre. "Nancy Spero," *Parachute,* September/October/November 1982, p. 28.
Lippard, Lucy R. "Caring: Five Political Artists," *Studio International,* vol. 193, no. 987, 1977, pp. 197-207.
———. "Nancy Spero's 30 Years War," *Village Voice,* April 19, 1983.
Lubell, Ellen. "Nancy Spero," *Arts Magazine,* vol. 49, January 1975, p. 9.
———. "Nancy Spero," *Arts Magazine,* vol. 51, November 1976, pp. 34-35.
———. "Notes on Women," *Soho Weekly News,* January 25, 1979.
Nelson, Lin. "An Interview with Nancy Spero," *Dialogue,* March/April 1980, p. 45.
Perreault, John. "Women Ain't Losers," *Soho Weekly News,* September 23, 1976.
Philbin, Anne. "Individual Assessments: Women and Art," *Dialogue,* March/April 1980, p. 42.
Robins, Corinne. "Nancy Spero: 'Political' Artist of Poetry and Nightmare," *Feminist Art Journal,* Spring 1975.

———. "Words and Images Through Time: The Art of Nancy Spero," *Arts Magazine,* vol. 54, December 1979, pp. 103-05.
Schjeldahl, Peter. "Opposites Attract," *Village Voice,* April 15, 1981.
Sedaitis, Judith. "Nancy Spero," *East Village Eye,* June 1983, p. 32.

Books

Lippard, Lucy R. *From the Center.* New York: E.P. Dutton & Co., Inc., 1976.
Naylor, Colin. *Contemporary Artists.* London: St. Martin's Press, 1977.

Artist's Writings and Other Published Works

Antonin Artaud: 4 Texts, trans. by Clayton Eshleman and Norman Glass. Los Angeles: Panjandrum Book, Inc., 1982. [illustrated by the artist]
"Ende," *Women's Studies,* vol. 6, Gordon & Breach Science Publishers, Ltd., Great Britain, 1978, vol. 6, pp. 3-11.
"Ongoing Dialogue Goes On," *Women Artists Newsletter,* vol. 1, no. 9, February 1976, p. 2

MARIANNE STIKAS

ARTIST'S STATEMENT

The joys of dealing with the abstract in terms of notions of reality seems a just cause. The result, in terms of painting is clearly an afterthought of the vices of nature.

Born in Washington, D.C., 1947. Attended the Art Students League, New York (1965); Corcoran School of Art, Washington, D.C. (1966–68); Maryland Institute College of Art, Baltimore (B.F.A. 1971); Virginia Commonwealth University, Richmond (M.F.A. 1974). Lives in New York City.

SELECTED SOLO EXHIBITIONS

1973–Marsh Gallery, University of Richmond, VA 1974–Graduate Thesis Exhibition, Anderson Gallery, Virginia Commonwealth University, Richmond, VA 1975–Wilson College, Chambersburg, PA 1976–Eric Schindler Gallery, Richmond, VA; 2nd Street Gallery, Charlottesville, VA 1978–Feigenson-Rosenstein Gallery, Detroit, MI (also '80) 1979–Holly Solomon Gallery, New York (also '81) 1980–Galerie Liatowitsch, Basel, Switzerland; Cutler/Stavaridis Gallery, Boston, MA 1983–Baskerville + Watson Gallery, New York

SELECTED GROUP EXHIBITIONS

1973–Rusk House Gallery, Davidson College, Davidson, NC 1974–*Annual Painting Exhibition,* Southeastern Center for Contemporary Art, Winston-Salem, NC; *19th Area Exhibition,* Corcoran Gallery of Art, Washington, D.C. 1975–*Seven Women Painters,* Wilson College, Chambersburg,

PA; *Chrysler Museum Painting / Sculpture Biennial,* Chrysler Museum, Norfolk, VA 1976 — *Irene Leach Exhibition,* Chrysler Museum, Norfolk, VA; *Faculty Exhibition,* Anderson Gallery, Virginia Commonwealth University, Richmond; *Summer Invitational,* Anderson Gallery, Virginia Commonwealth University, Richmond; *Ten Women Artists,* Southeastern Center for Contemporary Art, Winston-Salem, NC 1977 — *New Work / New York,* The New Museum, New York 1978 — *Silver and Gold,* Holly Solomon Gallery, New York; *Double Take,* The New Museum, New York; *Six Contemporary Artists,* List Arts Center, Kirkland College, Clinton, NY 1979 — *Summer Group Show,* Holly Solomon Gallery, New York; *Pfaff / Provisor / Stikas / Wells,* Holly Solomon Gallery, New York 1980 — *Painting and Sculpture Today,* Indianapolis Museum of Art, IN (exh. cat.); *Drawings,* Leo Castelli Gallery, New York 1982 — *Small Works,* Getler / Pall Gallery, New York 1983 — *New Decorative Works,* Jacksonville Art Museum, FL (exh. cat.); *Five Painters,* Getler / Pall Gallery, New York

SELECTED BIBLIOGRAPHY

Articles and Reviews

Frank, Peter. "Art: Funky Funky But Small," *Village Voice,* January 22, 1979, p. 69.

Ittner, John G. "Confetti and Pipes," *New York Post,* November 2, 1979, p. 53.

Larson, Kay. "Art," *Village Voice,* September 24, 1979, p. 87.

Perlberg, Deborah. "Review," *Artforum,* vol. 17, no. 6, February 1979, p. 71.

"Photo Album," *Bolaffi La Revista Dell' Arte,* August / September 1981, p. 79.

Printz, Neil. "New Faces / New Images; Marianne Stikas," *Ocular,* Summer 1981, pp. 66-67.

Ratcliff, Carter. "New York," *Arts International,* vol. 25, no. 1-2, January / February 1982, p. 116.

Shulman, Daniel. *Art in America,* vol. 71, no. 3, March 1983, p. 31.

Zimmer, William. "Marianne Stikas," *Soho Weekly News,* November 8, 1979, p. 58.

ROBERT YOUNGER

ARTIST'S STATEMENT

re: "The Sign of the Beast: *Revelation 13-18* "

Originally there were five heads in a drawing — very small drawing — done while watching *Super Bowl 14.* Using the proportions of a domino and titled with the names of those watching the game (Stanley, Glen, Jerry, Douglas, and Robert), this diagram sat dormant for several years until I thought of constructing a "Head House" — a big square head illuminated from within like a jack-o-lantern. Then I remembered the Super Bowl drawing which, considered in the third dimension, was closer in proportion to the Aku Aku, Easter Island heads. And slowly I became obsessed with the idea of an omnipotent, condescending, internally luminated head (Tiki God). A little voice inside kept repeating over and over, "The heads, the heads" until the image clearly became Dennis Hopper in *Apocalypse Now* with all those decapitations lying around.

About this time I spoke to Lynn Gumpert, who instigated my rereading of *Revelation,* which narrowed it all down to either the "Bottomless Pit" or the "Sign of the Beast (666)," which of course reminded me of that building at 53rd and Fifth with the sign on its forehead.

Born in Philadelphia, Pennsylvania, 1947. Attended Philadelphia College of Art, Pennsylvania (B.F.A. 1969); Yale University Graduate School of Fine Arts, New Haven, Connecticut (1971 – 72); Drexel University, Philadelphia, Pennsylvania (1975 – 79). Lives in New York City.

SELECTED SOLO EXHIBITIONS

1972 — *Polyethelene,* West Chester State College, PA 1973 — Art Shows, Philadelphia, PA 1974 — *A Most Rare Memorial of that Accursed First Generation of Men,* OIC Gallery, Philadelphia, PA 1975 — *Women are Sensitive,* Art Shows, Philadelphia, PA 1976 — *Reading Stands,* Stockton State College, Pomona, NJ; Nexus Gallery, Philadelphia, PA; *The List,* WXPN-FM and Institute of Contemporary Art, Philadelphia, PA [performance] 1977 — Nexus Gallery, Philadelphia, PA; *Tail form Two Cities,* Philadelphia, PA and New York [performance] 1978 — *Art on the Radio,* WUHY-FM, Philadelphia, PA [performance] 1979 — *Brainstorming,* West Chester State College, PA; *Five Easy Pieces,* Etage Gallery and Temple University, Philadelphia, PA [performance]; *Slave Making in its Most Vicious Form,* Etage Gallery, Philadelphia, PA [performance]; *Valium 5 mg. or Thorazine Too,* Philadelphia College of Art, PA [performance] 1980 — *Room of Malady,* Barbara Gladstone Gallery, New York; *Sexually Contagious Relations,* Pennsylvania Academy of Fine Arts, Philadelphia

1982 – *S₁B₂P₃*, Barbara Gladstone Gallery, New York 1983 – *Nidification,* Institute for Art and Urban Resources at P.S. 1, Long Island City, NY

SELECTED GROUP EXHIBITIONS

1970 – *Fulbrights,* American Embassy, Rome, Italy 1973 – *Five Recent Graduates,* Philadelphia College of Art, PA 1974 – *Made in Philadelphia II,* Institute of Contemporary Art, Philadelphia, PA; *Outdoor Sculpture,* Temple University, Philadelphia, PA; *Sculpture,* Philadelphia College of Art, PA 1975 – *Just Neon,* Columbia University, New York; *Five from Philadelphia,* Fifth Street Gallery, Wilmington, DE; *Sidewinder (Sam Shepard),* Lighting with Bricolage Theater, Philadelphia, PA [performance] 1976 – *Philadelphia / Houston Exchange,* Institute of Contemporary Art, Philadelphia, PA; *Group Show,* Nexus Gallery, Philadelphia, PA; *Artists Books,* Philadelphia College of Art, PA; *Violence Monologues,* Bricolage Theater, Philadelphia, PA [performance]; *Two by Two,* Bricolage Theater, Philadelphia, PA [performance] 1977 – *Outdoor Sculpture,* Temple University, Philadelphia, PA; *Nexus Group Show,* Philadelphia Art Alliance, PA; *Seveso,* Bricolage Theater, Philadelphia, PA; *Tiger Mountain,* Bricolage Theater, Philadelphia, PA [performance] 1978 – *Landfill / Racial Slur,* Artpark, Lewiston, NY (cat. by artist); *Night Marks,* Bricolage Theater, Philadelphia, PA [performance] 1979 – *Collections and Accumulations,* Eric Mackler Gallery, Philadelphia, PA 1980 – *Recipients of Fulbright Fellowships,* Philadelphia College of Art, PA 1981 – *Figuratively Sculpting,* Institute for Art and Urban Resources at P.S. 1, Long Island City, NY; *The Page as Alternative Space: The Last Decade,* Franklin Furnace, New York 1982 – *Art on the Beach,* Creative Time, Battery Park Landfill, New York; *Lambastings / Lamentations,* with Charles Guarino, Franklin Furnace, New York [performance]; *New New York,* State University of Florida, Tallahassee (exh. cat.; text by Albert Stewart; traveled) 1983 – *Fulbright Alumni Show,* Pace University, New York; *Illumination,* Museum of Modern Art, Art Lending Service for General Electric, Bridgeport, CT; *Pavlov,* with Charles Guarino, Plexus, NY [performance]

SELECTED BIBLIOGRAPHY

Articles and Reviews

Silverthorne, Jeanne. "Philadelphia: Linda Hunn / Robert Younger," *Artforum,* vol. 18, no. 9, May 1980.
——. "Robert Younger: Nexus Gallery," *Arts Exchange,* 1978, pp. 32-33.

THE NEW MUSEUM OF CONTEMPORARY ART

PHOTO CREDITS

William H. Bengston, figs. 21, 23; Alan Kikuchi, fig. 6; David Lubarsky,
fig. 18; Frank Martin, fig. 1; Robert E. Mates, fig. 20; Kevin Noble,
fig. 10; Eric Pollitzer, fig. 8; David Reynolds, fig. 9; Zindman/Fremont,
fig. 14.

Design by Abby Goldstein
Typesetting by Candice Odell
Printing by Eastern Press